Fauvism

Fau... ...urned on or before the last
...tamped belo... 17.3.99.

Fauvism

Fauves and Fauvism

by

JEAN LEYMARIE

BOOKKING
international

Printed in Switzerland by
IRL Imprimeries Réunies Lausanne s.a.

Library of Congress Cataloging-in-Publication Data

Leymarie, Jean.
 Fauves and Fauvism.

 Translation of: Le Fauvisme
 enl. ed. of: Fauvism. 1959
 Bibliography: p.
 Includes index.
 1. Fauvism-France 2. Painting, French.
 3. Painting, Modern-20th century-France.
 I. Leymarie, Jean. Fauvism. II. Title
 ND548.5F3L4813 1987 759.4 86-43204
 ISBN 2-605-00304-3

CONTENTS

History and Significance. 7
Pre-Fauvism 19
Chatou 29
The Pointillist Phase 41
Collioure. 51
The Climax. 61
Fauvism-Expressionism 85

Notes 101
Events Year by Year 102
Bibliography 106
List of Illustrations 112
Index 117

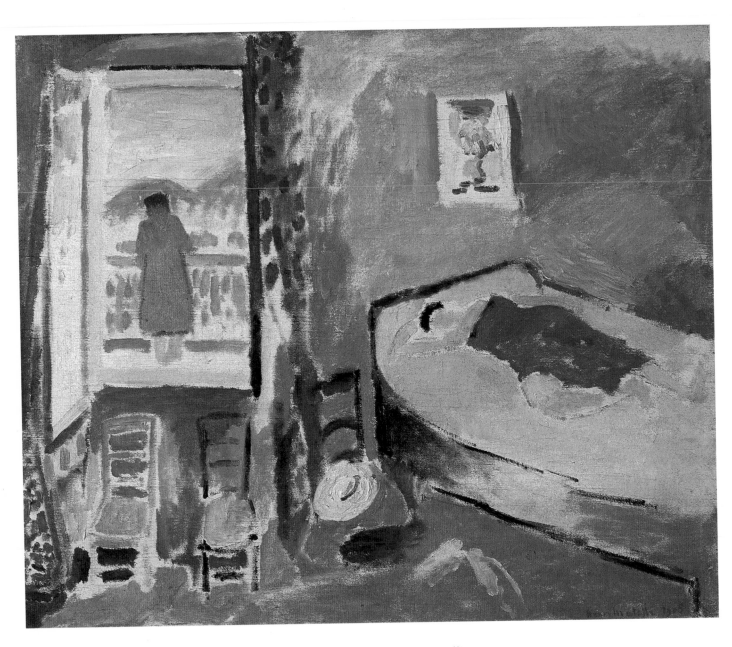

Henri Matisse (1869-1954): Interior at Collioure, 1905.

HISTORY AND SIGNIFICANCE

Excited handling of pure colors and drastic simplification of line—such was Fauvism, the first art revolution of the twentieth century. Neither a school nor a system, Fauvism, like all fruitful movements, was born of the chance encounter and common aspirations of a group of young, independent painters who reacted more or less alike to the climate of the times.

With Matisse as their ringleader, the Fauves were the center of attraction at the famous Salon d'Automne of 1905 in Paris. The explosive violence of their canvases touched off a scandal comparable to that of the First Impressionist Exhibition at Nadar's in 1874. "A pot of colors flung in the face of the public," was the indignant verdict of one critic, Camille Mauclair, who saw in this strange new art a threat to all accepted standards of decency and decorum. Even Gustave Geffroy, then one of the few defenders of contemporary art, who later prefaced the catalogue of Vlaminck's second one-man show, was baffled at first by these "color eccentricities," which drew down a storm of insult and mockery, just as Manet's *Olympia* and Monet's *Gare Saint-Lazare* series had done years before.

But a name was wanted. Louis Vauxcelles, avant-garde critic of the *Gil Blas*, came to the rescue (just as he was to do again in 1908 when he coined the term Cubism). To cushion the shock perhaps, several pieces of traditionalist sculpture stood in the room that had been set apart for the works of the new group. There, amid canvases whose shrill and garish colors clamored for the visitor's attention, Vauxcelles noticed a child's torso and a woman's bust of Florentine inspiration (they were the work of the sculptor Albert Marque) and exclaimed to Matisse who was standing nearby: "Look! Donatello in a cage of wild beasts *(chez les fauves)*!" This quip was reported in the *Gil Blas* of October 17 and the term "Fauve" caught on at once; its fortunes were made the following year when the "wild beasts," out now in full force, staged spectacular demonstrations at the Salon des Indépendants and the Salon d'Automne.

A similar movement, but expressionist in tendency, was getting under way at the same time in Germany, first at Dresden, then at Munich, with the collaboration of several Slav painters who were born colorists. Fauvism, then, was in the nature of a collective paroxysm; it was the climax of a long preparatory phase but, as is the way with paroxysms, it could not sustain the tension for long. As its dynamism subsided, other forces came into play. But it lasted long enough to launch twentieth-century art on its destined path toward subjectivism and total freedom.

The name Fauvism, like the names Impressionism and Cubism, was coined as a joke by an outsider; it evokes something of the virulence and shock tactics of the Fauve cult of pure color, but nothing of the aims, ideas and techniques behind the movement. No name or catchword, moreover, could possibly cover the diversity of its elements, nor is this true of Fauvism alone. It is a great fallacy, prevalent in our times, to predicate the general characteristics of a given art movement, and then to assess each member of it separately, according to the greater or lesser degree in which he typifies an abstract principle laid down at the outset. To make the man fit the movement—or worse, to make him fit the *label* of the movement—is a common illusion of the theorist. Courbet complained of it well over a hundred years ago: "The label Realist has been imposed on me just as the label Romantic was imposed on the men of 1830. Such labels have never conveyed an accurate idea of things; had it been otherwise, the works themselves would be unnecessary."

For only those works endure which are genuinely creative, and which are authentic reflections of their age. The picture content is not necessarily limited by any pre-existent aesthetic frame of reference; this is especially true of modern art, which unfolds as a kind of unforeseeable experiment continuously adding to its stock of experience. History, of course, is always a matter of hindsight and we read it in reverse, but there are certain essential works that stand out from the rest, and when they are replaced in the order and milieu in which they first appeared, the revolutionary trends they represent are seen to crystallize around the painters who produced them; and these works, above and beyond systems and theories, constitute the significant poles of attraction and influence. Variously shaped by the energies and sensibilities of each generation, by drives of instinct or self-imposed disciplines of the mind, these works carry on that endless regrouping of forms and colors which we call the history of painting.

Cubism—i.e. the analysis of form and objective differentiation of space—was the simultaneous invention of two modern masters whose contrasting gifts proved to be mutually enriching, and who, in their complementary efforts, were "roped together like a couple of mountain climbers," as Braque, the ex-Fauve, later described it. The beginnings of Cubism can be traced unerringly and its methodical progression followed step by step. Fauvism—i.e. the excited handling of color and

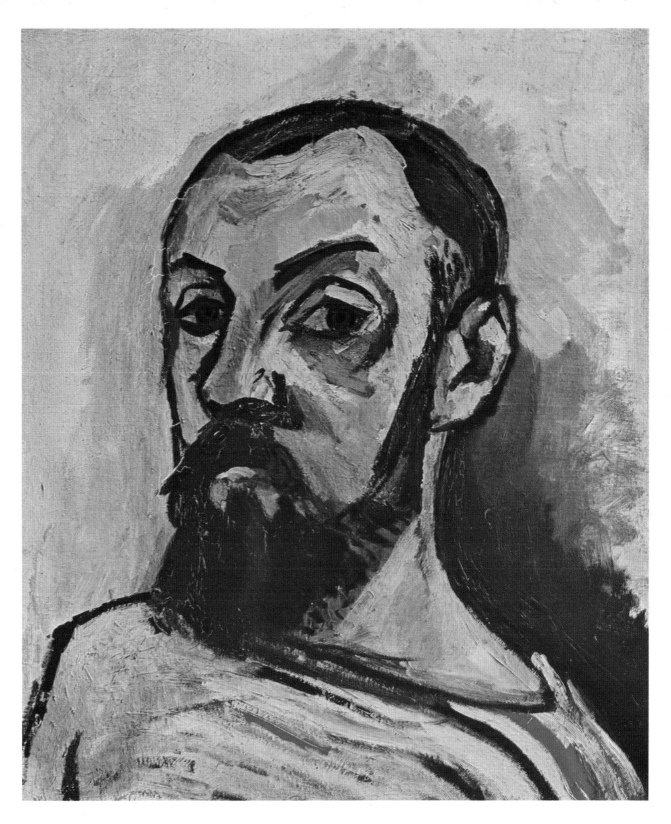

Henri Matisse (1869-1954): Self-Portrait, 1906.

subjective possession of the picture surface—neither appeared so suddenly nor developed so methodically. It was a less cohesive movement by reason of its emotional character, and by reason too of the number and varying abilities of its adherents.

Three principal groups, together with an isolated Dutchman, Kees van Dongen, contributed to the rise of Fauvism in France. The first steps were taken by the student painters from Gustave Moreau's studio and the Académie Carrière: Matisse, Marquet, Camoin, Manguin, Puy. Then came the boisterous pair from Chatou: Vlaminck and Derain. The last converts were a trio of young men from Le Havre, nourished on Impressionism: Friesz, Dufy and Braque. Fired with juvenile enthusiasm, individualists to the core, they joined forces in the art schools and galleries of Paris, exchanged ideas and were welded into a group thanks to the prestige and strenuous activity of Matisse, their elder and acknowledged leader of the movement.

Admitted to the Ecole des Beaux-Arts in 1895, Henri Matisse entered the famous studio of Gustave Moreau, where Rouault had been working for the past year and where he was joined in turn by Camoin, Manguin and Marquet. Moreau's whole-hearted, liberal-minded instruction fostered individualism. He fortified his pupils against the bloodless academicism of the day by holding before them the double example of the Old Masters and daily life. When this great teacher died in 1898 and was replaced by Cormon, an intolerant reactionary, the best students in the class withdrew.

In February 1899, after a year in Corsica and the Toulouse region, Matisse returned to Paris with a whole collection of rough sketches painted boldly in pure tones, emerald greens and madder reds, with scintillating textural effects and echoes of Pointillism. In order to work from the living model, he enrolled in the so-called Académie Carrière, an informal art school in the Rue de Rennes where Eugène Carrière dropped in each week to correct the students' work; there Matisse met Jean Puy and André Derain, both of whom came under his influence. Matisse's efforts to synthesize his earlier experiments, combined with his violent use of pure colors (hitherto restrained by his patient study of values), now produced a series of landscapes, still lifes and nudes characterized by compact, angular forms and saturated with purples, blues, oranges and vermilions. Followed at a cautious distance by Camoin and Manguin, Matisse exhibited yearly at the Salon des Indépendants from 1901 on, together with Puy and Marquet. The latter often accompanied him on his painting trips and shared his enthusiasm to the full. "As early as 1898," Marquet tells us, "Matisse and I were working in what was later to be called the Fauve manner. The first exhibitions at the Indépendants in which we were, I believe, the only ones to paint in pure tones, go back to 1901."

As for André Derain, who had already been turned out of the Louvre for making outrageous copies of the Old Masters, he had been on friendly terms since July 1900 with Maurice Vlaminck, a self-taught artist who was a law unto himself. They took a studio together at Chatou, on the western outskirts of Paris, and often worked out of doors, setting up their easels in the full glare of the sun and excitedly squeezing their paints "from the tube straight on to the canvas," impelled by sheer exuberance rather than by any plastic considerations. All the Fauves-to-be were swept off their feet by the Van Gogh retrospective at Bernheim-Jeune's in 1901, and it was during a visit to this exhibition that Derain introduced Vlaminck to Matisse. Thus was formed, with Derain as intermediary between two contrasting temperaments, the basic triangular relationship whose offspring was Fauvism.

Claude Monet (1840-1926): Street decked with Flags, 1878.

The years 1898-1901 were marked by a preliminary grouping of forces, set in motion on the one hand by Matisse and Marquet in the shadow of the Nabis and Neo-Impressionists and under the structural influence of Cézanne; and on the other by Vlaminck and Derain under the powerful impact of Van Gogh. This early period of pre-Fauvism was very different from the jubilant effusions of 1905-1907, in which the decorative patterning of Gauguin prevailed over other influences.

From 1901 to the end of 1903, Matisse systematically emphasized line and, except for an occasional outburst of color, toned down his palette (as did also Marquet and Puy); at the same time, to sharpen his grasp of forms and volumes, he took up sculpture. Derain was away on military service from 1901 to 1904. Vlaminck worked alone at Chatou, holding aloof from the ferment of the Paris art world. Spurred on by the revelation of Van Gogh, he—unlike Matisse— intensified his colors and during this transitional period poured them on to his canvas with all the lusty exuberance of his nature. It was on the strength of these paintings that Vlaminck later claimed credit as the originator of Fauvism.

A compatriot of Jongkind and Van Gogh, Kees van Dongen settled at Mont-martre in 1897 (just as they had done before him) and led the impecunious life of a Bohemian, before becoming the fashionable portraitist of high society. From Le Havre, home of Boudin and Monet whose work inspired their early efforts, came three young painters who had all studied under that excellent teacher Charles Lhuillier, the local equivalent of Gustave Moreau: Friesz in 1898, Braque and Dufy in 1900. It was also in 1900 that Picasso paid his first visit to Paris and sold a picture to Berthe Weill, whose tiny gallery on the lower slopes of Montmartre became the sanctuary of the new art. With courage and foresight, at a time when no one else was interested in them, she took up Matisse and Marquet in 1902, Puy, Camoin, Dufy and Manguin in 1903, Friesz, Derain, Vlaminck and Van Dongen in 1905, and featured them regularly in one-man shows and group exhibitions. During these heroic years, when their work had practically no sale value, only a handful of dealers were willing to gamble on them; and these were either eccentrics like Père Soulier, who ran a bric-à-brac shop and bought pictures from them as early as 1902, or genuine enthusiasts like Antoine Druet, a photographer, picture restorer and friend of Rodin, who opened a Paris gallery in 1903.

The Salon des Indépendants and the Salon d'Automne were open to them, however, and there they exhibited regularly. Founded in 1884 by Odilon Redon and the Neo-Impressionists, the Salon des Indépendants entered on a period of intensified activity in 1901 with the participation of Matisse, Marquet and Puy, joined in 1902 by Manguin, in 1903 by Friesz, Dufy and Camoin, in 1904 by Van Dongen and Valtat, in 1905 by Derain and Vlaminck, in 1906 by Braque—nearly all of whom figured there yearly up to 1910. But the very fact that there was no

jury and that all artists had the right to exhibit tended to bury the good work under an avalanche of inferior pictures. Hence the need soon felt for a new Salon, a little more discriminating, with a liberal-minded jury who could be relied on not to discourage young painters with bold ideas, but to eliminate cranks and medievalists.

The Salon d'Automne was founded to meet this need, in 1903, by the architect Frantz Jourdain, with the active support of Rouault, Marquet, Vuillard and, among the older men, Redon, Cézanne, Carrière and Renoir. While the Salon des Indépendants was held in the spring and usually featured studio compositions executed during the winter, the new Salon (as its name indicated) was held in the autumn, enabling artists to present their summer production, much of it open-air work. And while the former was limited to painting and sculpture, the latter included architecture, music, literature and all forms of decorative art, and moreover welcomed foreign artists. Both organized retrospective exhibitions, notably those devoted to Seurat, Van Gogh, Gauguin and Cézanne, all of whom were still unknown to the public at large, and these had the effect of speeding up the evolution of Fauvism.

Henri Matisse (1869-1954): Signac Fishing and Derain Swimming, 1904.

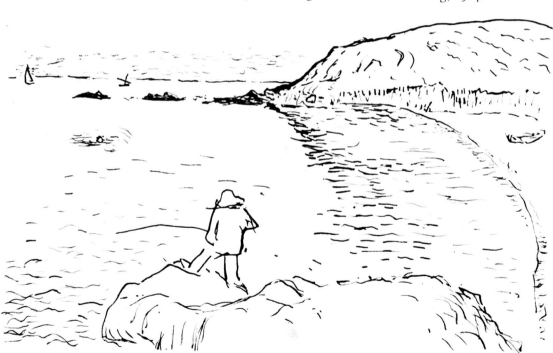

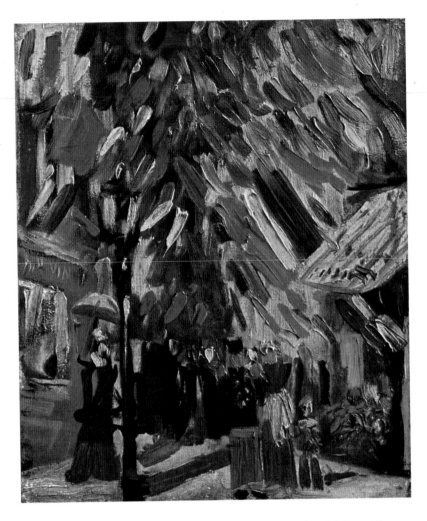

Vincent van Gogh (1853-1890): The Fourteenth of July, 1887.

After exhibiting at Vollard's in June 1904, Matisse spent the summer at Saint-Tropez, on the French Riviera, with Signac and Cross. The three men worked together and Matisse tentatively adopted their pointillist technique. Manguin, Camoin and Marquet, each in turn, went to Saint-Tropez the following year, so that in addition to Louis Valtat, an independent painter admitted to their circle who combined the manners of Cross and Renoir, most of the Fauves-to-be went through a pointillist phase essential to the flowering of their style.

At the 1904 Salon d'Automne Matisse exhibited several canvases in this new manner, and Othon Friesz was converted to the movement when he saw them. Friesz later defined the aims of Fauvism as follows: "To render the equivalent of sunlight by means of a technique based on color orchestration, by emotional

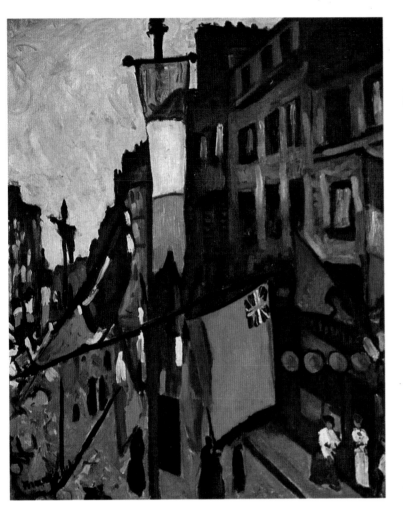

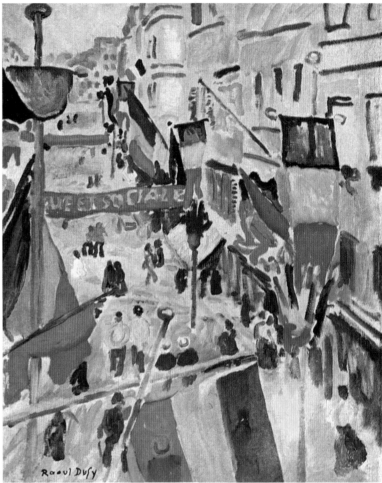

Albert Marquet (1875-1947): The Fourteenth of July, 1906. Raoul Dufy (1877-1953): The Fourteenth of July, 1906.

transpositions (with the emotions inspired by nature as our point of departure) whose truths and theories were built up in the course of enthusiastic research work." At the 1905 Salon des Indépendants Matisse exhibited a large pointillist composition, sketched out in the south, which he had just finished in his Paris studio: *Luxe, calme et volupté.* Now it was Raoul Dufy's turn to be converted at the sight of "this miracle of the creative imagination at play in color and line." The two Havre painters abandoned the impressionism of their earlier work and began initiating themselves into the "pictorial mechanics" of Matisse.

In the autumn of 1904 Derain came home from the army. Now began a fresh period of active give-and-take between Matisse and the two young men of Chatou, who manipulated their color tubes like "dynamite cartridges." Derain and Matisse

spent the following summer together at Collioure, just south of Perpignan, and there, under the blazing southern sun, the stimulating interchanges between these two rich and lucid natures produced the first canvases which can truly be described as Fauve. These created a sensation at the historic Salon d'Automne of 1905, where they figured beside those of Marquet, Manguin, Friesz, Puy, Valtat, Vlaminck and Van Dongen.

Two very important things to note are the participation at the 1905 Salon d'Automne of the Russian colorists Jawlensky and Kandinsky, and the exactly contemporary appearance at Dresden of a corresponding movement, known as *Die Brücke* (The Bridge), launched by Kirchner, Heckel and Schmidt-Rottluff. At about the same time in France and Germany the eyes of all these artists were being opened to the arts of Africa and Oceania which, gradually superseding the lingering vogue of Japanese prints, cast a spell over them all—before casting it over the Cubists.

The cult of primitive art combined with total freedom in the handling of color —these were the determining factors of Fauvism and the first man to put them into practice was Gauguin to whom tribute had been paid by a memorial exhibition at the 1904 Salon d'Automne, pending the more comprehensive Gauguin retrospective of 1906. The trend toward primitivism was further strengthened by the great exhibition of French Primitives held in 1904 at the Pavillon de Marsan, in Paris, where it had been preceded by an exhibition of Islamic art greatly admired by Matisse. The 1905 Salon d'Automne presented a Manet retrospective, and the role of this great precursor must not be underestimated. "He was the first," wrote Matisse, "to react directly, thus simplifying the painter's craft... expressing only what immediately impinged on his senses." With him there was no gulf, nor even any distinction, between perception and spontaneous expression; and this is also true of Fauvism, which in a sense reflected the contemporary philosophy of intuition as expounded by Benedetto Croce and Bergson. "I can make no distinction," confessed Matisse, "between the sense I have of life and the manner in which I express it." Art, then, is a pure transfer, an act of empathy, in which object and subject coincide absolutely.

Gauguin was the first after Manet to practise modern flat-color patterning and to exploit the expressive and spatial value of pure tones, and his influence was paramount in the Paris of 1906, the year in which Fauvism came to full fruition. Braque now joined the group under the influence of Friesz, with whom he worked at Antwerp throughout the summer, while Marquet and Dufy, painting side by side in Normandy, were producing their most flamboyant canvases, notably their versions of *The Fourteenth of July*. Vlaminck set up his easel as usual along the Seine banks at Chatou, Derain painted views of the Thames in London, and Matisse

worked in the Mediterranean sunlight of Collioure; all three stepped up the intensity and brilliance of their palettes. For color was now being used for its own sake, independently of the subject, and light and space were generated by color alone. Fauvism had created a mature style of its own, and its triumph at the 1906 Salon d'Automne was complete. Kandinsky, then on a visit to France, was greatly impressed, and so was his friend Jawlensky a few months later when he met Matisse and saw his work. At Dresden the Brücke group, still in close sympathy with the French movement, organized its first exhibition in 1906, so that Fauvism now seemed to be blossoming out into an international style; soon, however, the link was broken as the Brücke artists progressively cultivated a thoroughly Germanic form of expressionism.

Hardly had Fauvism reached its peak in France when the unity of the movement was disrupted in 1907 by the meteoric rise of Cubism, launched by Braque and Picasso, though Matisse and Derain had also cleared the way for it. Cézanne's influence now predominated over Gauguin's. By 1908, when Matisse, after painting a magnificent series of masterpieces, formulated his aesthetic theories in his *Notes of a Painter* and justified the new role assigned to color, Fauvism had ceased to exist as a concerted movement. Some of the Fauves lapsed into neo-classicism, others into a ponderous neo-realism. Only Matisse and, in another key, Dufy were able to prove how fruitful its principles were, and to develop them to the full. For all, however, this period of heroic exaltation served, as Derain put it, as an "ordeal by fire" which purified painting and liberated color, while revealing some of the finest, most original talents of modern art.

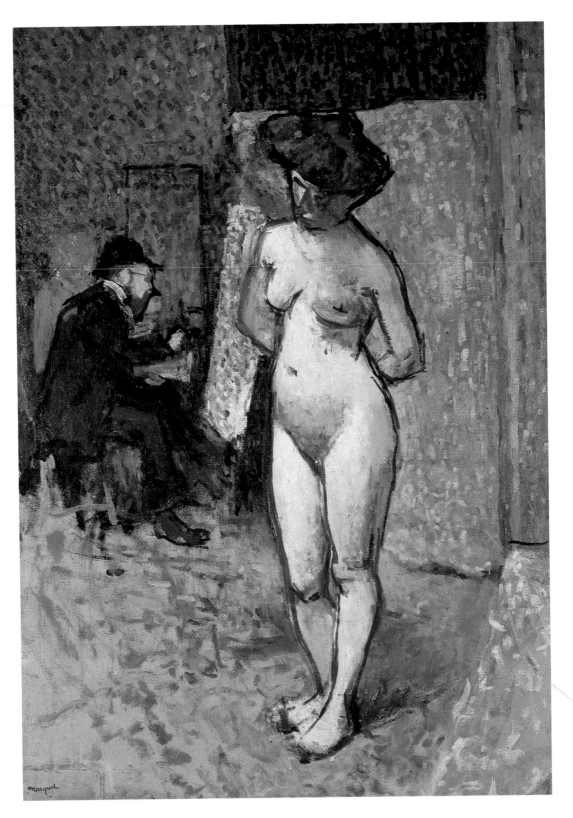

Albert Marquet (1875-1947): Matisse Painting in Manguin's Studio, 1905.

PRE-FAUVISM

"To say that color has once again become expressive is to sum up its history. For a long time it merely served as a complement of design. Raphael, Mantegna and Dürer, like all the painters of the Renaissance, constructed the picture by line, adding local color afterwards.

"On the contrary, the Italian Primitives, and the Orientals even more, used color as a means of expression...

"From Delacroix to Van Gogh and chiefly to Gauguin, by way of the Impressionists, who cleared the ground, and Cézanne, who gave the final impulse and introduced colored volumes, we can follow this rehabilitation of color's function, this restoration of its emotive power."

So wrote Matisse, whose own development exemplified that ascension toward color which connects Fauvism both with its immediate sources and with the oldest traditions of art. Born in 1869 in Picardy, in northern France, Matisse remained unaware of his artistic vocation till he was twenty. Then, to help him while away the time during a convalescence, his mother gave him a box of paints. "I felt transported," he wrote, "into a sort of paradise in which I was gloriously free, at ease and on my own." He gave up his law career and, after a struggle, won his father's consent to go to Paris and study art. He attended first the Académie Julian, then the Ecole des Beaux-Arts, where he met a taciturn, hard-working young man from Bordeaux, six years his junior, Albert Marquet, and they became lifelong friends. In Gustave Moreau's studio he found a stimulating atmosphere and "intelligent encouragement." He received a cordial welcome from the senior members of the class, Desvallières, Rouault, Evenepoel and Piot, while his abilities and devotion to his work attracted to him the best of the newcomers: Flandrin, Camoin, Manguin, Marquet, and Linaret, a very promising painter who died young. "I am the bridge," Moreau told them, "over which some of you will pass." He also observed that "in art the more elementary your means are, the more your

sensibility shows through"—a precept which he himself never put into practice, but which was not lost on his students. To Matisse he predicted: "You are going to simplify painting."

But Matisse was in no hurry to do so and made a point of proceeding methodically. Before tackling the problems of color and surface patterning, he made a thorough study of values and of variations of light and texture within a scale of muted colors. "A sensitive painter, adept in the art of greys," was Evenepoel's comment on Matisse. At the Louvre he copied Chardin, Poussin and the Dutch masters, and trained his hand on still lifes and interiors.

He was oriented toward the themes and technique of Impressionism by two summer stays at Belle-Ile in Brittany, in 1896 and 1897, where he met the Australian painter John Peter Russell, a close friend of Rodin and Monet, who gave him two drawings by Van Gogh. Between those two summers Matisse painted a large composition, *The Dinner Table*, in which he synthesized his classical training and his recent venture into Impressionism and prefigured the personal style of his maturity. A harmony of blue-green and golden brown, intensified by the contracting of the picture space, glows through a density of texture inspired by Chardin.

Like Bonnard, Matisse collected Japanese prints; he was received in Rodin's studio by the master himself, whose brilliant watercolors and dynamic sensuality made a lasting impression on him; and, sometimes accompanied by Manguin, he began his visits to Pissarro whom he fervently admired. Moral arbiter and artistic guide of his time, Pissarro had received Corot's teachings at first hand; he had decisively influenced Cézanne and Gauguin, recognized Van Gogh's genius, and defended Seurat—the four creators of modern art. And now, nearly seventy, as generous and open-minded as ever, he took a keen interest in the early efforts of Matisse, Manguin and Friesz, and gave them advice which they never forgot. At Pissarro's suggestion, Matisse eliminated the whites which at first formed the central support of his *Dinner Table*. Then, following his instinct, he boldly executed nudes in pure blue and enamel-like still lifes in orange and scarlet. Here were the beginnings of an eruption of color in which Marquet also shared, and which gathered strength up to 1901. This was the prelude to Fauvism.

After getting married in January 1898, Matisse and his wife spent a few weeks in London where he studied Turner, as Monet and Pissarro had done before him. This was followed by six months in Corsica, where he discovered the Mediterranean world and revelled in it; then six months near Toulouse, his wife's country. This was a year of freedom and relaxation for Matisse, after the strain of a long apprenticeship, and he let himself go, dashing off open-air sketches bright with chrome yellow, emerald green and madder red—colors not so much suggested by the motif as generated by his visual excitement. The exuberant brushwork recalls

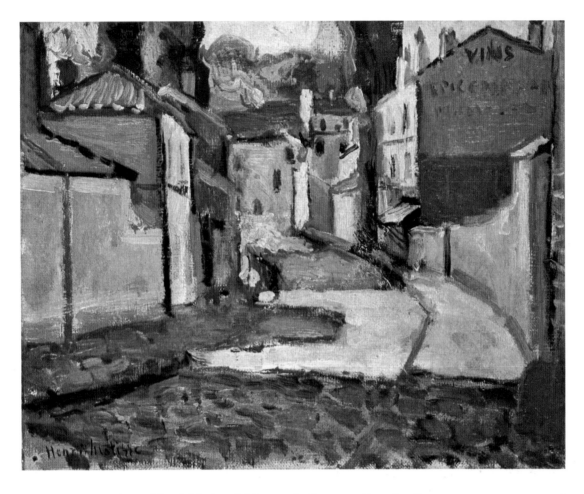

Henri Matisse (1869-1954): Street at Arcueil, 1899.

Renoir's, but the touch of the brush is hastier, now sweeping on the paints, now dotting them across the canvas, while the vibrant tones are more distinct, less blended, than Renoir's.

Back in Paris in February 1899, Matisse took a studio at 19 Quai Saint-Michel, where he lived till 1907, throughout his Fauve period. Though now thirty, Matisse felt that he still had much to learn and went on copying Chardin at the Louvre. He resumed his studies at the Ecole des Beaux-Arts, but Moreau's place had been taken by Cormon, whose tyrannic narrow-mindedness was more than he could bear. Together with Marquet and Camoin, who had become close friends in his absence, he left the class and they worked, as Moreau had recommended, in the museums and the city streets. Called up for three years' military service in 1899, Camoin was stationed first at Arles, where he revisited Van Gogh's old haunts, then

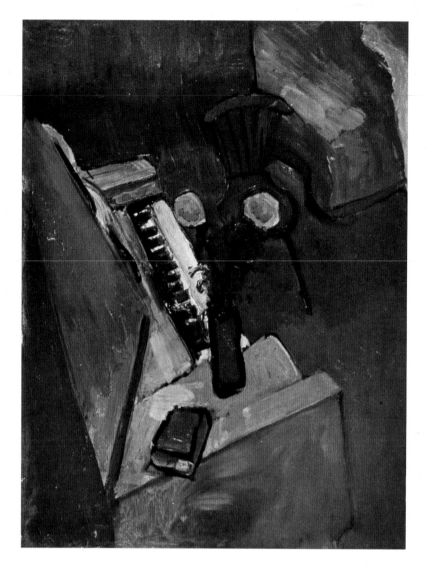

Henri Matisse (1869-1954): Still Life with a Harmonium, 1900.

at Aix-en-Provence, where he was cordially welcomed by Cézanne. Meanwhile Matisse and Marquet went out painting together in Paris almost daily. Mornings and afternoons they worked from nature at Arcueil or in the Luxembourg Gardens, saturating their powerful studies with pure tones; in the evenings they sketched in the music halls and café-concerts, cultivating, like Lautrec and Bonnard before them, the knack of jotting down impressions on the wing. It is important not to underestimate the linear side of Fauvism (for its spate of color was accompanied

by a new boldness of design), and here Marquet was unsurpassable; he handled line, as Matisse acknowledged, with a speed and sureness worthy of Hokusai.

By now the rash of Pointillism, which had broken out all over their canvases in 1898, had been absorbed by other influences. For some time Matisse had had his eye on a Van Gogh for sale at Vollard's, but the price was higher than he could afford, so instead he bought Cézanne's *Bathers*, Gauguin's *Head of a Boy* and a plaster cast by Rodin. In 1900 he bought two pastels by Odilon Redon and struck up a friendship with this dazzling colorist, so much admired by Gauguin and the Nabis. Still poor and unknown, Matisse strained his meager resources to the limit to buy these works, not simply because they had caught his fancy, but because he found in each an object lesson in artistic creation. Cézanne was then his most fruitful source of inspiration, not only for the handling of pure colors but as a model of structure and vital energy. It was Cézanne who made him realize that "tones are the force in a picture," that their relationships must be soundly balanced and their

Henri Matisse (1869-1954): Still Life against the Light, 1899.

progression fully worked out. His influence took effect conspicuously in two outstanding works of 1899: *Still Life against the Light*, orchestrated in a sumptuous harmony of red and orange, and *Street in Arcueil*. The slightly later *Still Life with a Harmonium* is an even bolder work whose bird's-eye perspective and dynamic color scheme foreshadow the great still lifes and interiors of around 1912.

Matisse's prime concern, however, was with the human figure. When he returned to Paris from Toulouse in 1899, he formed the habit of working at the Académie Carrière. There he met Jean Puy, Derain, Laprade, Biette and Chabaud, all younger men who were attracted by his commanding personality and discerning judgment. "He was something like the mentor of our small group, his word carried weight," wrote Derain, to which Jean Puy added: "He owed his ascendancy as much to the esteem and implicit trust which his cordiality inspired in us, as to the bold, almost reckless confidence with which he was already expressing himself in painting."

From 1899 to 1901, as a matter of fact, first at the Académie Carrière, then at Jean Biette's studio in the Rue Dutot, where Matisse and his friends clubbed together to hire a model, he executed a series of male and female nudes rendered with slashing brushwork in vivid colors. "He had no hesitation," wrote Puy, "about resorting to extreme, wholly artificial means. Very often, for example, he laid in the side planes of the nose and the pools of shadow under the eyebrows with an almost pure vermilion, which heightened the color scheme of the head and the projection of nose and brow, or again some of his nudes looked as if they were wearing orange slippers." Painted sometimes in greens and violets, more often in cobalt blue enlivened with orange and carmine, these rugged, uncouth nudes seem to have been hacked out with a chisel. Matisse freed himself from studio conventions by an uncompromising vehemence of expression both in line and color. The "extreme, wholly artificial means" which dumbfounded Puy were a necessary step toward the conquest of his style.

Marquet worked at his side in friendly rivalry. "I would sometimes begin a canvas in a bright tonality," he wrote, "then, as I went on with it, end up on a greyish note." Not out of timidity, nor because (as we learn from Matisse) he was too poor to buy colors, but because Marquet had already realized that at bottom he was a harmonist, not a colorist. His originality lay in the sureness of his drawing, which he perfected by countless pen and oil sketches; his sensibility came out in his gradations of values. Marquet showed from the start a love of movement, a keenly observant eye which always saw the humorous side of things, and a natural leaning toward contemplation. When copying at the Louvre he was instinctively drawn to Fragonard and Rubens, to Corot and Chardin, above all to Claude Lorrain. To begin with, however, from 1897, he used pure tones in his landscapes,

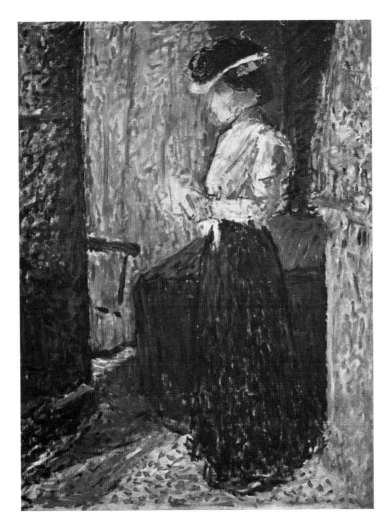

Albert Marquet (1875-1947): Portrait of Madame Matisse, 1901.

still lifes and nudes, and applied them in a generous, almost passionate profusion. One of Marquet's most significant early works, known appropriately enough as *Fauve Nude*, dated 1898, was undoubtedly painted in Gustave Moreau's studio; an exactly parallel version by Matisse, almost certainly anterior to his trip to Corsica, is painted in the same rapid, pointillé technique. In Marquet's *Portrait of Madame Matisse* of 1901, the vibrant touches of blue, green and yellow tersely bringing out the dainty silhouette fade into the mauve and orange hangings in the Vuillard manner. At this time the group that had formed around Matisse came under the influence of the Nabis, who had received from Gauguin the talisman of pure color.

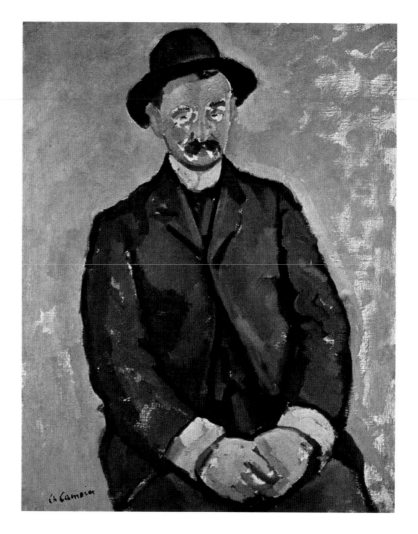

Charles Camoin (1879-1965): Portrait of Marquet, 1904.

After a spell of Pointillism in 1898 and an initial outburst of Fauvism around 1900, tensely structural and anti-decorative in character, Matisse toned down his palette for the time being, the better to emphasize volumes and masses, and worked hard at sculpture under the aegis of Barye and Rodin. Proceeding as usual by advancing boldly and then retracing his steps to make sure of his ground, he aimed at the full possession of a complete technique, exhaustively testing out every means of expression. Without quite discarding pure tones, which still blazed up in his landscapes and still lifes, Matisse went through a rather dark period of his art (and of his life) from late 1901 to late 1903, a transitional phase between values and colors. With three children to support and very little money coming in, he was

obliged to live with his parents in 1902 and again in 1903, while his wife opened a milliner's shop and posed for him in her leisure moments. Hence the many figure studies he painted now, neutralizing his palette in order to build up a solid linear groundwork which he laid out with a plumb-line. Under the influence of Marquet, who worked almost daily in the vicinity of Notre-Dame and Pont Saint-Michel, he also painted several views of the Cité along a plunging line of sight.

It was during this intermediate period that Puy, Camoin and Manguin, who were to represent the moderate side of Fauvism, began to reveal themselves. Thanks to their natural spontaneity and their fidelity to Impressionism, they met with a more immediate success than Matisse and Marquet did. Camoin, youngest of the group, had just been discharged from the army when he exhibited at the 1903 Salon des Indépendants and sold six canvases, one of them bought by Signac. His *Portrait of Marquet* (1904) is both an affectionate tribute to his friend and a very fine picture. As fluid as the watercolors of Cézanne's last phase (Camoin was in touch with Cézanne and continued to correspond with him), his colors are neatly demarcated by the firm, elliptical drawing which closely approximates to the design of Marquet's contemporary *Portrait of Rouveyre*; their common source is Manet's *Fifer*. Manguin, who was fairly well off, kept open house to his friends in the large studio he had taken in 1900 in the Rue Beursault, where they often worked together and confabulated. In 1901 Manguin summered with Marquet in Normandy, before going south and brightening his palette in the Mediterranean light. He combined, perhaps a little too urbanely, the warm-hearted vitality of Renoir and the structural balance of Cézanne.

Under the beneficent influence of Matisse, Jean Puy painted several bold nudes and portraits, simplified, brightly colored works, before adopting the synthetist vision of Gauguin, with muted colors and a forcible technique appealing directly to the senses. He painted regularly in Brittany, at Belle-Ile, and in the vicinity of Roanne, his home town. A modest, retiring artist, Puy jealously guarded his admirable drawings from the public eye; this, together with the rapid dispersal of his youthful pictures, accounts for the fact that his early work long failed to receive the appreciation it deserves.

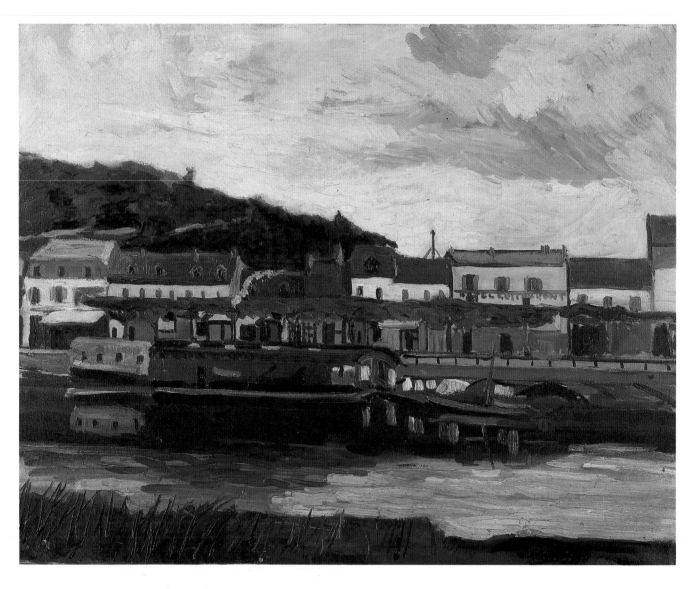

Maurice Vlaminck (1876-1958): Banks of the Seine at Nanterre: Quai Sganzin, 1902.

CHATOU

A charming town on the Seine in the west suburbs of Paris, Chatou has been called the Argenteuil of Fauvism. There two of the Fauves fanned their colors to a blaze, and there began the friendship of the three pioneers of the movement, Matisse, Derain and Vlaminck.

Derain was born and bred at Chatou and Vlaminck had been living there since 1892, but they did not meet till 1900. For several months Derain had been attending the Académie Carrière in Paris, where he had just met Matisse. Coming home in the train one evening in June, he found himself sitting opposite a tall, husky young man a few years older than himself—Vlaminck. The compartment was nearly empty and they soon got into conversation. As it so happened, the locomotive jumped the tracks before the train reached Chatou, so they walked into the village together, talking all the way. A close friendship sprang up between them at once; temperamentally very different, but equally outspoken, equally strapping and athletic, both were full of youthful enthusiasm for painting.

They went out painting together the day after they met. "Each of us set up his easel," related Vlaminck, "Derain facing Chatou, with the bridge and steeple in front of him, myself to one side, attracted by the poplars. Naturally I finished first. I walked over to Derain holding my canvas against my legs so that he couldn't see it. I looked at his picture. Solid, skillful, powerful, already a Derain. 'What about yours?' he said. I spun my canvas around. Derain looked at it in silence for a minute, nodded his head and declared, 'Very fine.' That was the starting point of all Fauvism."

And Vlaminck goes on, with his usual breeziness and volubility: "What Fauvism is? It's me. It's the manner I had in those days, the way I revolted and set myself free all at once, the way I broke away from the School, from bondage: my blues, my reds, my yellows, my pure, unmixed colors. As for Derain, he must have caught the infection from me." This is a Gargantuan overstatement, a typical

example of Vlaminck's swashbuckling egoism, for the "infection," as we have seen, came in the first instance from Matisse, to whom both Derain and Puy loyally paid tribute as the pioneer of the movement.

So this historic encounter does not really mark the birth of Fauvism, though it inaugurated one of its main centers of activity, easily the most spectacular, often referred to (a trifle pompously) as the School of Chatou. A close and fruitful collaboration began between the two young painters. "Time and again," wrote Derain, "I would accompany Vlaminck to his door, he would walk back with me to my place. I would see him home again, then he would accompany me, and so on till daybreak. A few hours later, off we went again with our color boxes and easels. We were always drunk with color, with words that describe color, and the

Maurice Vlaminck (1876-1958): Man with a Pipe (Le Père Bouju), 1900.

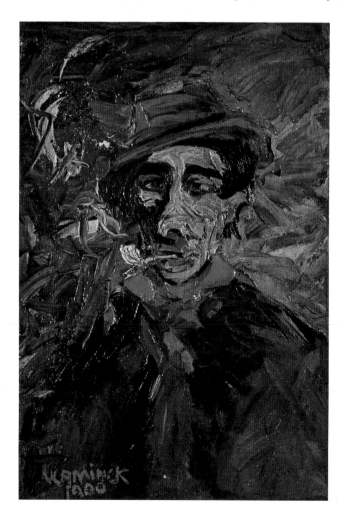

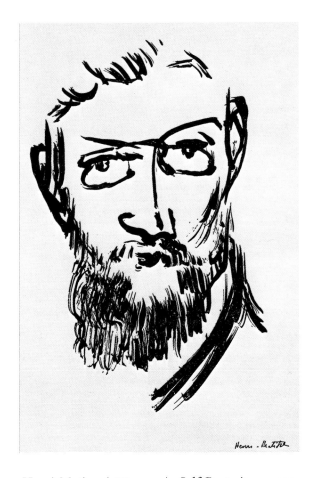

Henri Matisse (1869-1954): Self-Portrait, c. 1900.

sun that gives life to color." It was not long before they took a studio together in the Island of Chatou in the Seine, renting for ten francs a month the main room of an abandoned house near the inn run by Mère Fournaise, where in 1881 Renoir had painted his *Luncheon of the Boating Party.* "From there," wrote Vlaminck, "we could see the village of Chatou, the laundry barge tied up alongside the river bank, the steeple, the church, carters leading their horses to the watering place, the carts of market gardeners crossing the bridge"—and these were the dynamically treated themes of their first pictures.

Derain was just twenty in 1900. His parents, well-to-do tradesmen, had given him a sound classical education and intended to make an engineer of him, but in his teens he was already painting, attending art school, visiting museums, and leafing through art books: "By the time I was eighteen I was familiar with all the available reproductions of masterpieces. What's to be gained by lacking culture?"

Vlaminck, on the contrary, wholly self-taught and chafing at authority, boasted of never having set foot in the Louvre and relied on himself alone: "Visiting museums only saps your personality, just as consorting with priests makes you lose your faith." He was already twenty-four and father of two children when he was discharged from the army in September 1900. It was during his last leave of absence, in June, that he met Derain.

Born in Paris, near the Halles, Vlaminck grew up at Le Vésinet, then one of the poorer suburbs of Paris. At sixteen he set up for himself at Chatou, making a living as a racing cyclist and playing the violin in cafés in the evenings. "The discovery of the world for me begins with the bicycle," which—pending the invention of the motorcycle and automobile, which were to delight him in later years—gave him his "first sensations of space and freedom." Already the Fauves were in love with speed: the dreamy languors of Impressionism were giving place to an increasingly accelerated vision.

Vlaminck's parents were both musicians who seem to have led a Bohemian life, leaving him to his own devices. On his father's side he came of north-country stock: among his ancestors were Dutch sailors and Flemish farmers, and from them he inherited his strapping physique, his love of the open air, his gregarious exuberance. Perhaps to his mother, a Lorrainese protestant, he owed that taste for argumentative confession (and accusation) which led him to rewrite his self-complacent autobiography at least ten times, with the same ingenuous truculence —and the same undeniable talent. If Paris attracted him as a tantalizing field of experiment and temptation, at heart he was a rustic and he settled in the country as soon as he could afford to do so. The gold of ripe wheat and the snowdrifts of midwinter never failed to quicken his sense of wonder. As a child, he was sung to sleep by sentimental lullabies; he collected the penny sheets of soldiers in bright uniforms that are known in France as *images d'Epinal*, copied the colorprints that came in the packages of chicory his mother bought, and marvelled at the "works" of a neighboring saddle-maker who painted the villagers' portraits on glass in the same harsh tints he used for horse-collars. Later he discovered the Impressionists in the gallery windows at Durand-Ruel's and Vollard's.

Except for a mediocre decorative panel painted while he was in the army, nothing remains of Vlaminck's work prior to 1900. Dating from that year is the rugged *Man with a Pipe*, dashed off at one sitting in a thick impasto which, though not yet incandescent (except in the ruddy reds of the neckerchief), anticipates the Fauvism of 1905-1907; its overwrought accents reflect the wave of expressionism then spreading over Europe. No sign here, however, of the monumentality or bold colors of Matisse's contemporary nudes. For Vlaminck's palette to flare up it had to be ignited by Van Gogh.

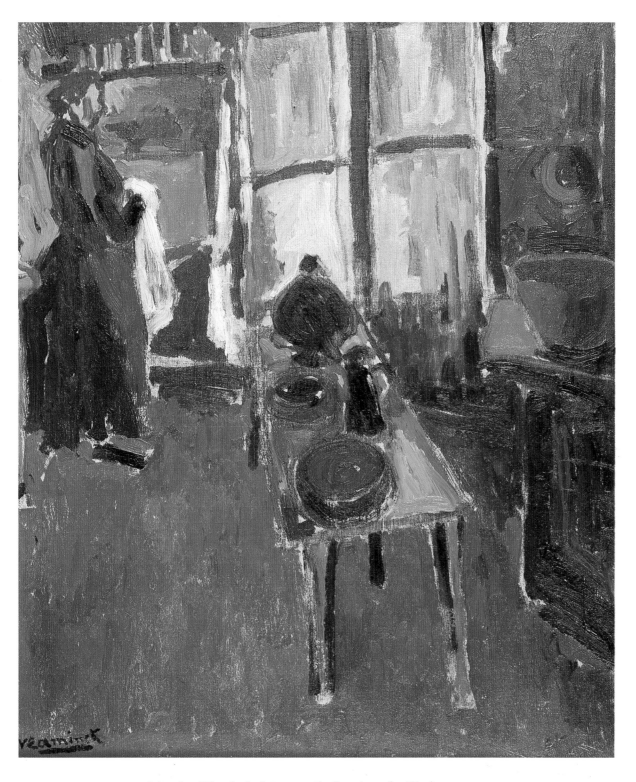

Maurice Vlaminck (1876-1958): Interior of a Kitchen, 1904.

This occurred at the famous Van Gogh retrospective at Bernheim-Jeune's in the spring of 1901, which produced such a strong impression on Hugo von Hofmannsthal and, "in the thick of a storm whose fury transported him with joy," led him to write his sublime letter on colors. Vlaminck too was amazed by what he saw and in the first flush of his enthusiasm declared, "I love Van Gogh better than my father!" He and Derain returned again and again to the exhibition, and on one of their visits they ran into Matisse, to whom Derain presented Vlaminck. Shortly afterwards Matisse went out to Chatou to see their work. Vlaminck, ignorant of everything Matisse had achieved up to that time, would have us believe that this meeting and the visit to Chatou were decisive for the older man, but Matisse has left a more objective account of this episode. "Looking in at the Van Gogh exhibition one day at Bernheim's, in the Rue Laffitte, I saw Derain accompanied by a young giant who was voicing his enthusiasm in dictatorial tones and

André Derain (1880-1954): The Bridge at Le Pecq, 1904.

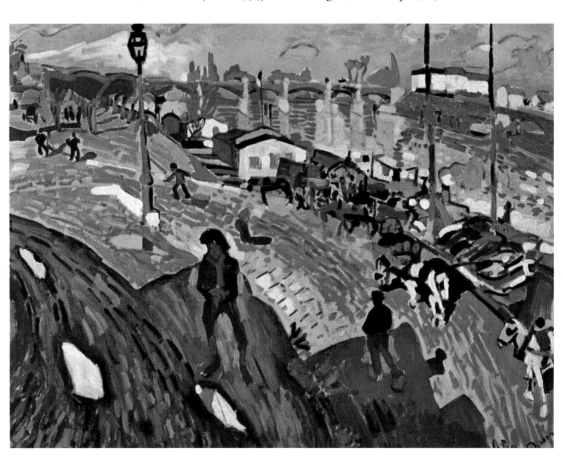

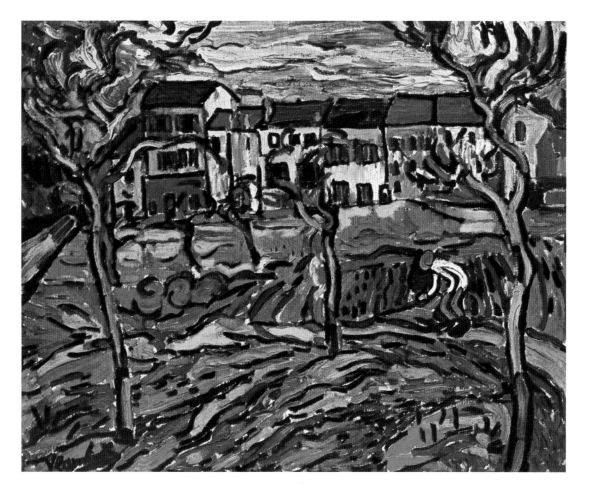

Maurice Vlaminck (1876-1958): Gardens in Chatou, 1904.

declaring that one must paint with pure cobalt blue, pure vermilion, and pure Veronese green. Derain, I think, was a little afraid of him, but admired his ardor and eagerness. He came up to me and introduced me to Vlaminck. Derain urged me to call on his parents in order to convince them that, contrary to what they supposed, painting was a respectable profession... To tell the truth, the painting of Derain and Vlaminck did not surprise me, for it was closely related to my own line of research. But I was moved to find that there were young men who had convictions similar to mine.''

Matisse and Vlaminck represent the opposite poles of Fauvism, and to them the movement owed its force and complexity. Their attitudes to painting were radically different. Matisse felt that ''instinct has to be kept down, it is like a tree which, when its branches are pruned, grows taller and handsomer.'' Vlaminck

"strove to paint with his heart and his midriff, without bothering about style... for the basis of art is instinct." Matisse accepted the classical heritage and admitted to having "never avoided the influence of others"; according to him, the artist's personality is strengthened and enriched by the conflicts it engages in and honestly resolves. Vlaminck, eager to assert himself, cursed at every restraint coming from outside. "I wanted to burn down the Ecole des Beaux-Arts with my cobalts and vermilions, I wanted to express my feelings without troubling what painting was like before me... When I've got the color tubes in my hand, I don't give a damn about other people's pictures. Life and me, me and life—that's all that matters."

Painting for Vlaminck was not an aesthetic experience but a visceral upsurge: "something welled up within me and I had to get it out of my system." And he added, making a clear distinction between his temperament—sentimental at heart, therefore aggressive—and his unruly behavior: "I was a soft-hearted tough. By instinct, unmethodically, I expressed not an artistic but a human truth." He was "the most authentic painter of us all," acknowledged Derain, who was torn between Vlaminck's undisciplined verve and Matisse's fine lucidity. "I've never worked," Vlaminck goes on to say, "I've simply painted, trying to make a natural gift yield everything it could give. I wanted to reveal myself to the full, with my qualities and my defects."

Van Gogh's impact on Vlaminck was not immediately perceptible, for the canvases of 1902, notably *Little Girl with a Doll* and *Quai Sganzin*, mark a recession with respect to those of 1900. But by 1903 his colors had been fanned to a flame. His *Pond at Saint-Cucufa*, with its glistening expanse of water, with trees and sky swept up in a passionate élan, attains a plenitude that Vlaminck never surpassed; its radiance is all the more intense for the fact that his colors are still held in check. By 1904, however, his whole palette had caught fire: here was Fauvism in the full sense of the word. Not only was Vlaminck the most advanced at that time, but he was the only one who realized where he was going. Matisse and his group —with whom Vlaminck, working alone at Chatou, was out of touch—were just beginning to emerge from their "dark period" and were reverting to Pointillism. Derain, who had been in the army since late in 1901, did not return home till the autumn of 1904. Those three lost years in the army made a break in Derain's career of which he was painfully conscious (he was still lamenting it shortly before his death). After being discharged, he was carried away by the infectious enthusiasm of Vlaminck, whose screens of receding trees and plunging lines of sight he borrowed, as he inaugurated his own cycle of Fauve pictures, taking his cue by turns from Gauguin and Van Gogh.

A comparison of Van Gogh's paintings with those of Derain and Vlaminck brings out clearly, despite the presence of a similar emotive intensity, the differences

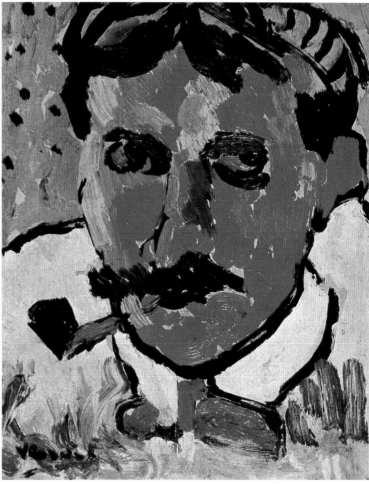

André Derain (1880-1954): Portrait of Vlaminck, 1905. Maurice Vlaminck (1876-1958): Portrait of Derain, 1905.

both in approach and pictorial structure between the two French painters and their great Dutch forbear. Each canvas by Van Gogh is a projection of his entire being, the logical culmination of an infinitely complex process of soul-searching. "Do not believe," he wrote to Theo, "that I keep myself artificially at fever pitch. I would have you know that I think out everything down to the last detail. The result is a quick succession of canvases painted at high speed, but carefully worked out long beforehand." Orchestrator of his own frenzy, which he channelled by projecting it on to canvas, he worked in a state of trance-like *concentration*—more exacting, as he said, than that of an actor on the stage—in order to "balance the six essential colors."

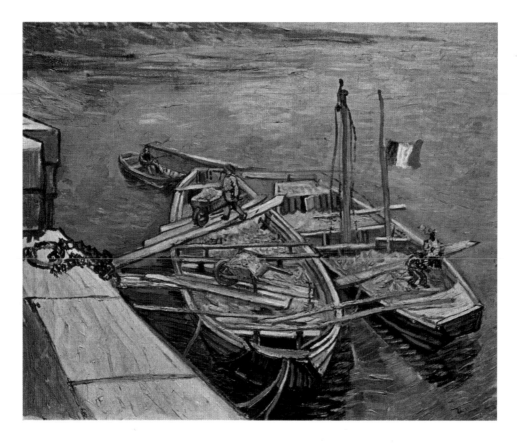

Vincent van Gogh (1853-1890): Boats Moored alongside the Quay, 1888.

Vlaminck, on the other hand, relying mainly on the three primary colors, red, blue and yellow, pressed straight from the paint tubes, touched off an *explosion*, sudden and spasmodic, whose violence is largely simulated. "My ardor led me to risk everything and hold back nothing, in defiance of all the conventions of the painter's craft... I felt neither jealousy nor hatred, but a consuming passion to create a new world, the world as I saw it with my own eyes, a world of my own. I heightened all my tones and transposed all the feelings I was conscious of into an orchestration of pure colors." He galvanized the texture of his canvas into a thick impasto of swirls and spirals, interrupted by vertical streaks of pure color heavily outlined in black *(Gardens in Chatou)*. He dispensed with shading, emphasized contrasts, hitting hard and, very often, effectively, compelling attention by his sheer driving force.

The charm of Derain's technique lay, on the contrary, in its elegance and virtuosity; his handling was suppler and lighter, his color schemes limpid and vivacious, his linework neater and more varied. His canvases, with their echoes of

Marquet and their anticipations of Dufy (notably in *The Bridge at Le Pecq*), are sometimes glossy and undulating, sometimes angular and convulsive. But all the schematic accents in the work of both Vlaminck and Derain are on the surface; the feverish characterization of objects and persons which so passionately interested Van Gogh has dwindled to a glittering tessellation of expressionist or decorative touches. A comparison of Van Gogh's *Boats Moored alongside the Quay* with Derain's *Seine Barges* shows that, even when their theme and composition are very much alike, their vision is fundamentally different.

André Derain (1880-1954): Seine Barges, 1906.

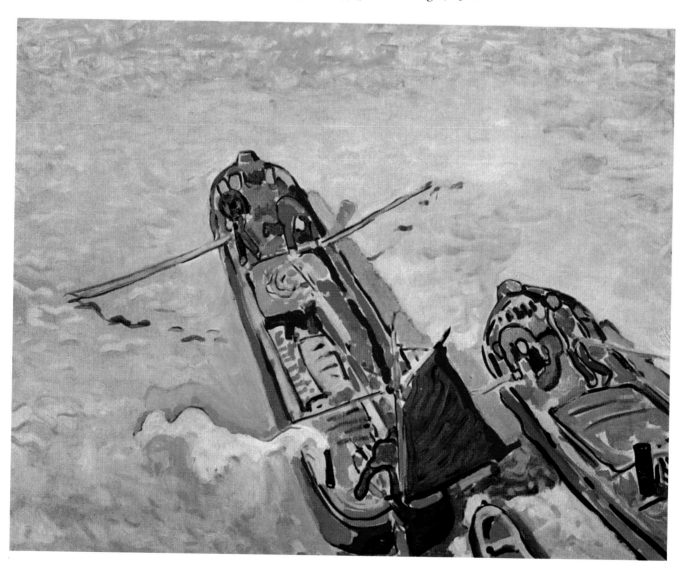

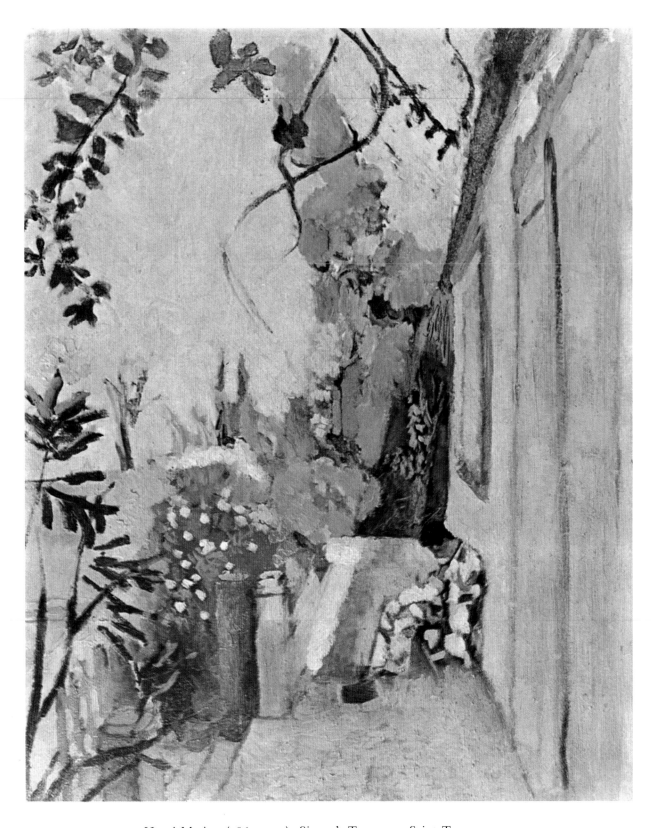

Henri Matisse (1869-1954): Signac's Terrace at Saint-Tropez, 1904.

THE POINTILLIST PHASE

THE primary concern of contemporary artists has been to preserve the unity of the picture surface as a flat plane devoid of illusionist effects of depth. In Seurat's technique we have the first modern example of an entirely homogeneous manner of painting, organized like a mosaic around the unity of a basic element which is, at one and the same time, a textural and an emotional element. Hence the revolutionary value of that technique and the periodic attraction it exerts on artists, especially in times of transition. Gauguin, Van Gogh and Lautrec did not work out a style of their own till after going through a more or less prolonged phase of Divisionism. And around the turn of the century Matisse and Marquet, like Vuillard and the Nabis, tried their hand at Pointillism, just as Kandinsky and Delaunay were to do after them.

In 1899 Paul Signac, theorist, continuator and proselytizer of the movement, published his famous essay *D'Eugène Delacroix au Néo-Impressionnisme*. After tracing the rise of Neo-Impressionism and defining its principles, he concluded with this prediction: "If, among the Neo-Impressionists, none has yet proved to be the artist whose genius will give compelling expression to the new technique, at least they will have served to pave the way for him. This all-conquering colorist has only to step forward: his palette stands ready for him."

In June 1904 Vollard organized Matisse's first one-man show. The catalogue was warmly prefaced by Roger Marx, who paid tribute to the artist's "exacting demands upon himself" and recognized, amid the diversity of his early styles, his determination "methodically to develop the gifts as a colorist with which nature has endowed him."

Matisse and his family spent the summer months of 1904 at Saint-Tropez, where Signac lived. Chairman of the Salon des Indépendants where Matisse, a regular exhibitor since 1901, had made his acquaintance, Signac had no doubt told him about the charms of Saint-Tropez and, most important of all, the low cost of

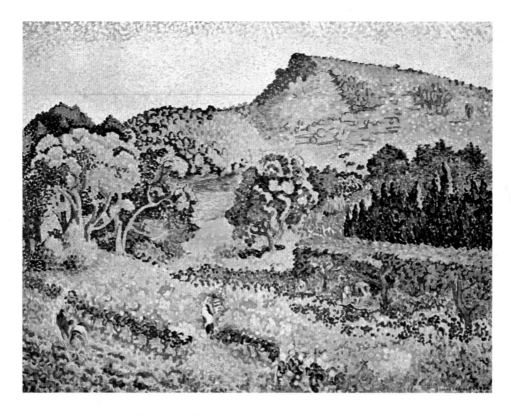

Henri Edmond Cross (1856-1910): Le Lavandou, 1904.

living in this little known village on the Riviera, which he had discovered in 1892 when it was still inaccessible except by sea. There Signac built his famous Villa La Hune, where in the intervals between his frequent cruises on the Mediterranean he played host to his friends and disciples; chief among these was Henri-Edmond Cross, who lived in the neighboring village of Le Lavandou, where he was often joined by Theo van Rysselberghe.

Put on his guard by Pissarro, Matisse had no intention of renewing his earlier venture into Pointillism, which was unsuited to his temperament. Still haunted by Cézanne, he began by painting several austerely constructed landscapes and still lifes, then surrendered to the Mediterranean atmosphere, which gradually relaxed the tension of his work. His colors brightened up and sang out again, and he indulged in startling contrasts of light, for example in *The Terrace, Saint-Tropez*, with Madame Matisse posing in a Japanese kimono.

Soon, however, he was won over again to Divisionism by Signac's persistent advocacy, but even more by the personal charm of Cross, who was less dogmatic, more easy-going and, in his good moments, a finer colorist than Signac. Unequal and often stilted in their oil paintings, the two divisionists turned out some

incomparable watercolors, fluid, vibrant, spontaneous works, almost Fauve in their chromatic intensity. Cross looked on with amusement at Matisse's efforts to conform to the "precise and scientific method." The initial results were rather disappointing, for in spite of himself Matisse not only laid stress on his dominants but also on his contrasts, instead of shading them off as the rules prescribed; he accused himself bitterly of "manhandling his colors," of failing to "control his line," which sprang to life insidiously beneath a shower of dot-like touches.

He practised out of doors and took as his theme the gulf of Saint-Tropez as seen from the far end of the pine grove. With its sharp vertical thrust, a tall pine on the right served to counterbalance the broken coastline which stretched across the canvas in a manner reminiscent of the calligraphic linework of Signac's watercolors. Matisse returned repeatedly to this familiar view of the bay, always from the same angle with the same tall bare pine on the right; gradually he took to enlivening it with figures, standing and reclining. Unlike Signac, Cross often peopled his landscapes with nymphs flitting among the trees or female bathers disporting themselves on the beach. Here no doubt, together with hints from the work of Maurice Denis, Puvis de Chavannes and of course Cézanne, we have the

Henri Matisse (1869-1954): Luxe, calme et volupté, 1904-1905.

origin of the major composition entitled *Luxe, calme et volupté* which Matisse executed the following winter in his Paris studio. Before leaving Saint-Tropez, he painted a glittering preliminary sketch of it which did away for good with the austerities of his dark period. Contours burst wide open under the flashing impact of color, which now parts company with nature and takes on a resplendent purity that is specifically Matissian.

Matisse returned to Paris for the second Salon d'Automne, which opened on October 15, 1904, no longer in the basement of the Petit Palais but in the spacious, well-lit galleries of the Grand Palais across the street. He exhibited fourteen of his latest works and Friesz, who now became acquainted with him, was so much struck by them that he forthwith abandoned the impressionist manner he had hitherto cultivated under the influence of Guillaumin and Pissarro, and plunged headlong into what he described as "color orchestrations" and "emotional transpositions."

Paris art life was then dominated by the activities of the Neo-Impressionists, which reached a climax with the Seurat retrospective at the 1905 Salon des Indépendants. The Druet Gallery showed works by Maximilien Luce in March 1904 and by Cross in March 1905 with, in the interval, the large-scale Signac exhibition of December 1904 prefaced by Félix Fénéon. "Carried away by this luminous Signac exhibition," wrote Jean Puy, "Matisse was a thoroughgoing pointillist for a whole year." He pondered over his impromptu experiment of the previous summer and decided now to see it through to its logical conclusion. His studio, Friesz tells us, was loud with discussions of contrasts and complementaries.

Two revealing canvases by Matisse and Marquet date from this period. The two friends portray each other at work on the same model in Manguin's studio; both, Matisse especially, are applying the divisionist technique to the difficult problem of rendering the human figure. According to his custom, Matisse reverted to themes he had treated before, reinterpreting them now in terms of Divisionism: for example, a *View of Notre-Dame* which is often reproduced, and *Still Life with a Purro*, of which he had painted a first version, still Cézannesque, in the early summer of 1904 at Saint-Tropez.

All his efforts to assimilate what he had learned are systematically summed up in *Luxe, calme et volupté*, which he sent to the 1905 Indépendants. There it was triumphantly acclaimed by Signac, who gave it a place of honor (and also bought the picture, which hung in the dining room of his villa at Saint-Tropez for the next forty years); it was the cynosure of all eyes and gave rise to passionate discussions. While admiring it in many ways, Maurice Denis and Louis Vauxcelles both cautioned Matisse, one against "the dangers of abstraction," the other against "experiments uncongenial to his true nature." It immediately brought about the enthusiastic conversion of the second young man from Le Havre, Raoul Dufy,

Raoul Dufy (1877-1953): The Port at Le Havre, 1905-1906.

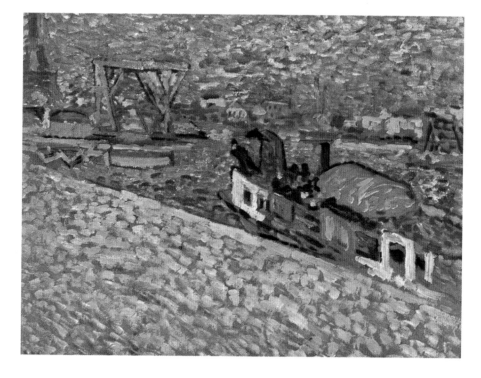

Louis Valtat (1869-1955): The Seine and the Eiffel Tower, 1904.

who had been exhibiting at Berthe Weill's and the Indépendants since 1903, and was already inclining toward Fauvism. "At the sight of this picture," he declared, "I understood the new *raison d'être* of painting and impressionist realism lost its charm for me as I beheld this miracle of the creative imagination at play in color and line."

An authentic profession of faith in Divisionism, *Luxe, calme et volupté* is also Matisse's first interpretation of the old theme of the classical pastoral, which he completely renovated. The title comes from Baudelaire's poem *L'Invitation au voyage*. While purely imaginary, the composition is not Arcadian in the same sense as those of Poussin or Puvis de Chavannes (though to the latter it owes a few iconographical details), but distinctly contemporary after the manner of Manet, who also combined nudes with figures dressed in the fashion of the day. The picture represents a group of female bathers picnicking on the beach at Saint-Tropez, which Matisse had studied from nature throughout the previous summer; four are seated or reclining, three are standing—one dancing, one plaiting her hair. All the colors of the rainbow are scattered over the picture in a dazzling mosaic, whose contrasts and harmonies, while not so scientifically organized as Signac's, have a richer chromatic intensity. Here and there a few lingering contour lines discreetly block out forms. The whole composition is built up around an intricate rhythm of verticals, diagonals and curves, powerfully counterbalanced by the median diagonal of the foreshore. In a single work Matisse seems to have synthesized Seurat's successive experiments with contrasts of tones, tints and lines.

Once he had gone beyond this stage, Matisse, like Pissarro before him, took a stern view of a doctrine which, based on merely "retinal sensations," aimed at a "purely physical arrangement of the picture content." Nevertheless, he greatly benefited by an experiment freely undertaken, and not only opportune but vitally necessary to the development of his art.

Up to 1906 Matisse remained largely dependent on the pointillist technique, especially in his landscapes. His example, coupled with the revelation of Seurat and the exhibitions at Druet's, gave rise to a veritable epidemic of Pointillism. Many of his friends also made the pilgrimage to Saint-Tropez and were initiated into its mysteries. "They all went down there," says Louis Vauxcelles, "like a flock of migratory birds. By the spring of 1905 there was a valiant little colony of painters painting and arguing in this enchanted region: Signac, Cross, Manguin, Camoin, Marquet." While never strictly abiding by the rules of Divisionism, they exulted in the splendor of the climate, stepped up their palettes, and sprinkled their canvases with dabs of pure color.

The most enthusiastic of them all was Manguin, who voiced his rapture in *The Fourteenth of July at Saint-Tropez*: gaily colored streamers and paper lanterns hung

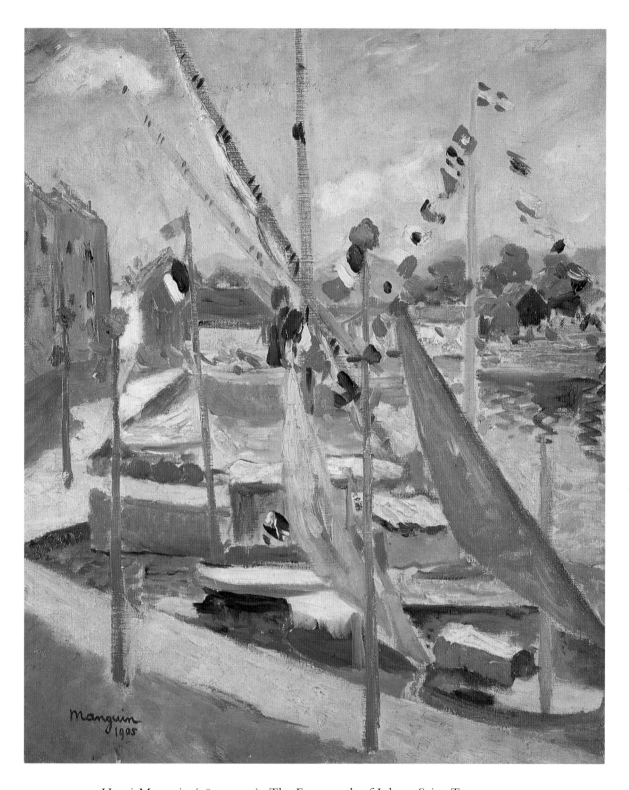

Henri Manguin (1874-1949): The Fourteenth of July at Saint-Tropez, 1905.

along the masts of sailboats re-echo the glistening reflections in the water. Delighted with the place, he—like Signac—was soon spending most of his time at Saint-Tropez. Near the port he fitted up a vast, light-filled studio, "L'Oustalet," as he called it, overlooking the bay on one side, with a view on the other of the Esterel and the chain of the Alps. Meanwhile Marquet and Camoin were working together at Agay, just up the coast, and often came over to Saint-Tropez on their outings.

Even those who were only remotely connected with Matisse and his group began dividing colors more or less systematically. This was notably the case with Louis Valtat who, though usually numbered among the Fauves, actually stands closer to the men of the previous generation, such as Maillol, Cross and Renoir. Several painting expeditions around the Mediterranean, in Provence, Spain, Italy and Morocco, led him to brighten his palette early in his career; but Valtat's colors, for all their vividness, only serve to clothe a conventional structure without

Maurice Vlaminck (1876-1958): Outing in the Country, 1905.

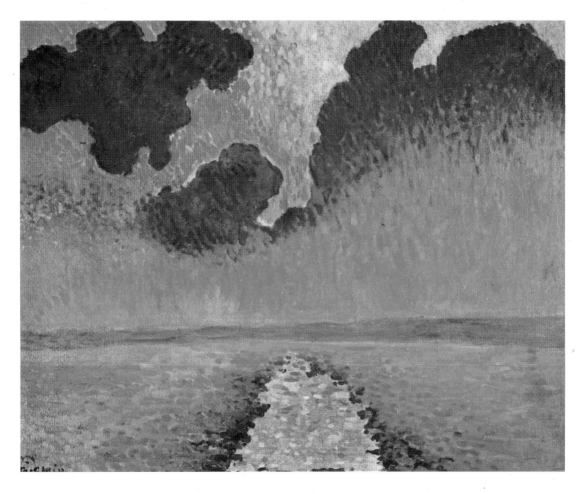

André Derain (1880-1954): Reflections on the Water, 1905-1906.

breathing new life into it. *The Seine and the Eiffel Tower* of 1904 keeps dutifully to the neo-impressionist technique, merely relaxing its rigidity and adding a few bold accents.

Vlaminck's impetuosity was such that he could seldom be bothered with the meticulous disciplines of Pointillism. But he often divided his colors in wildly tossing wisps of pigment in order to render the glow of sunlight and the exuberance of vegetation. His *Outing in the Country*, showing a Sunday couple picnicking under a tree, with grass and leafage swept up in concentric swirls of color, certainly conveys the mingled intoxication of wine, summer heat and young love.

Through Matisse, Derain assimilated the technique of Cross and Signac and transposed it, keyed up to an almost Turnerian lyricism, into the radiant, highly skilled harmonies of his Collioure and London pictures of 1905-1906, of which *Reflections on the Water* is an accomplished example.

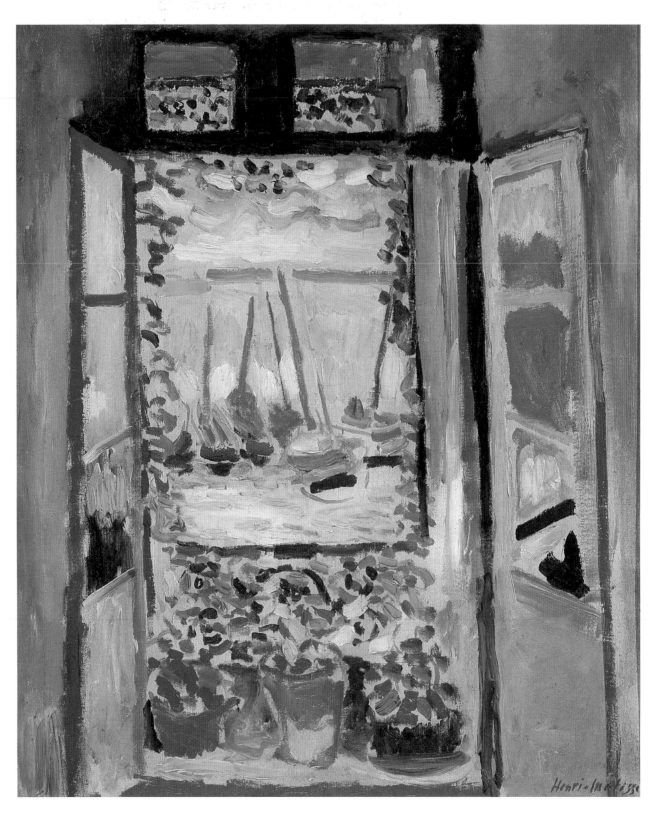

Henri Matisse (1869-1954): The Open Window at Collioure, 1905.

COLLIOURE

WITH Marquet, Puy, Manguin and Camoin as his assistants, Matisse was appointed by Signac chairman of the hanging committee at the 1905 Salon des Indépendants, which featured a double retrospective devoted to Seurat (44 items) and Van Gogh (45 items). Taking advantage of this opportunity to study their canvases at first hand, he was able to measure the gulf separating the fine crystallization of Seurat's own work—which lacked neither "human values" nor, in his sketches from nature, the technical inventions and sweeping brushwork which Matisse soon turned to account—from the rigid, almost anemic practices of his disciples. Now, moreover, Matisse was better prepared than in 1901 to assimilate the passionate message of Van Gogh and to discern the severe disciplines underlying it.

Again he called on Vlaminck and Derain at Chatou and, impressed by the boldness and excellence of their work, persuaded them to exhibit at the Salon des Indépendants; with the result that there, for the first time, a powerful group of colorists turned out in full force—to the dismay of orthodox critics. At a studio party Matisse and Vlaminck, one an amateur violinist, the other a semi-professional, performed a duet, which, however, was not a complete success because Vlaminck insisted on playing *fortissimo* all the time. "And the same is true of his painting," Matisse added slyly. He got along better with Derain, whom he took with him to Collioure for the summer holidays in 1905.

"I firmly believe that a new school of colorists will take root in the South of France," predicted Van Gogh, and set the example himself. The small Catalan seaport of Collioure, on the Mediterranean coast south of Perpignan, only a few miles from the Spanish frontier, became for Matisse and Derain what Gardanne, in the heart of Provence, was for Cézanne, and what Céret, only a few miles inland from Collioure, in the French Pyrenees, was soon to be for Braque and Picasso: one of those rare places where privileged painters ripen their vision and create a

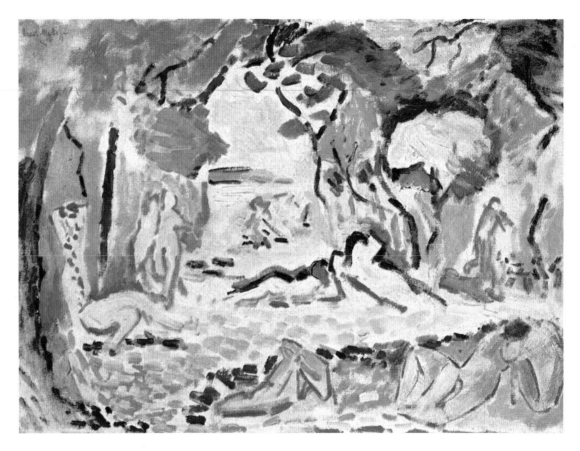

Henri Matisse (1869-1954): Sketch for The Joy of Life, 1905.

style. If Céret, as André Salmon put it, was the "Mecca of Cubism," Collioure was the birthplace of Fauvism, for it was there that the transition was now made from the Neo-Impressionism of Saint-Tropez to the new and brilliant manner that created a sensation at the 1905 Salon d'Automne. Every summer for the next ten years or so Matisse came back to Collioure, and the name is often used to designate this period of intense creation, the most significant of his career, before the glorious swan-song of his last years.

During this first summer he surrendered to the charm of this delightful region and painted joyfully alongside Derain, whose twenty-fifth birthday they celebrated together at Collioure on June 10, 1905. Thanks to the stimulating contact of Matisse, Derain now found his bearings for the first time since leaving the army. "I had spells of despondency," he said, "but Matisse always cheered me up." Their

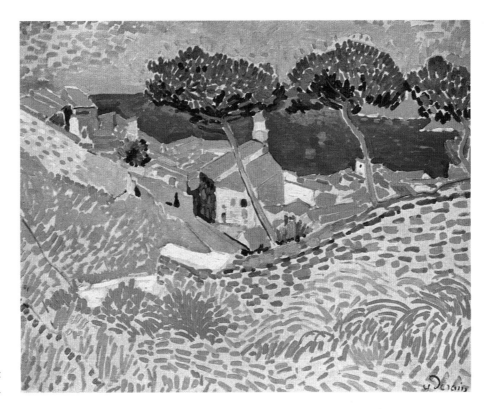

André Derain (1880-1954):
View of Collioure, 1905.

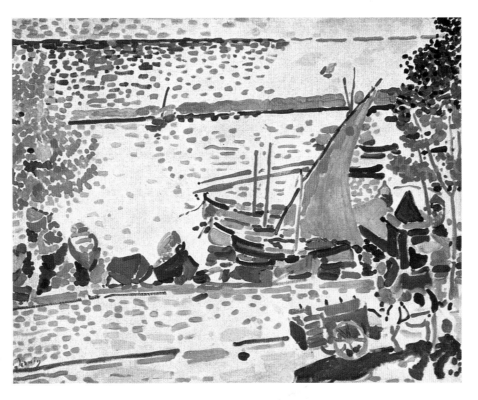

André Derain (1880-1954):
The Port, Collioure, 1905.

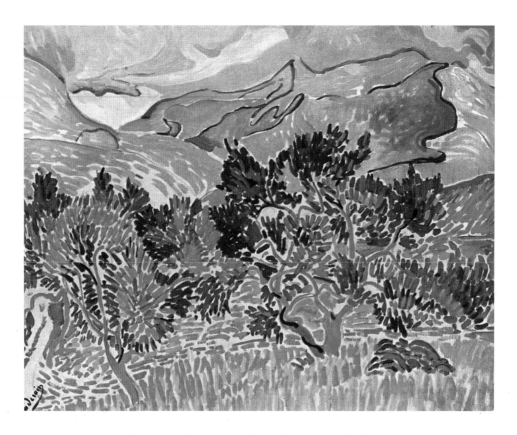

André Derain (1880-1954): The Mountains, Collioure, 1905.

portraits of each other bear witness to the mutual esteem and friendship which bound them together during that fruitful summer at Collioure. Charged with intense sincerity beneath their boldness of texture and tone, these two portraits form a pendant to the symmetrical portraits, more abrupt in treatment, of Vlaminck and Derain, executed that same year at Chatou. In addition to their documentary and psychological value, they enable us to compare the respective manners of the three outstanding Fauves and, in Derain's case, emphasize the difference between the more flexible Collioure style and the tenser style of Chatou. Often regarded as exclusively landscape painters, the Fauves also cultivated the portrait, notably the self-portrait and the reciprocal portrait; they were fond of those exchanges of portraits which Van Gogh had recommended and the old Japanese masters had practised.

Derain's letters to Vlaminck give us an intimate picture of his stay at Collioure and the change that came over him there. He rhapsodizes over the beauty of the

village, huddled between its old ramparts, with the squat forms and pure colors of its houses harmoniously rising from the sea to the foothills of the Pyrenees; he comments on the character of the villagers, on the quaintness of their costumes and their festivities, above all on the quality of the light—"a blond, golden light that does away with shadows." "It costs me a terrific amount of work," he added. "Everything I've done up to now seems pointless to me."

After the high-spirited improvisations of Vlaminck, Derain discovered now the methodical experimentation of Matisse, who recognized and stimulated the younger man's gifts, and made him conscious of the demands of composition and

André Derain (1880-1954): Portrait of Matisse, 1905.

Henri Matisse (1869-1954): Portrait of Derain, 1905.

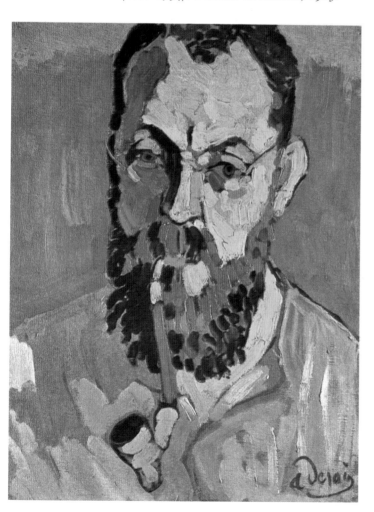

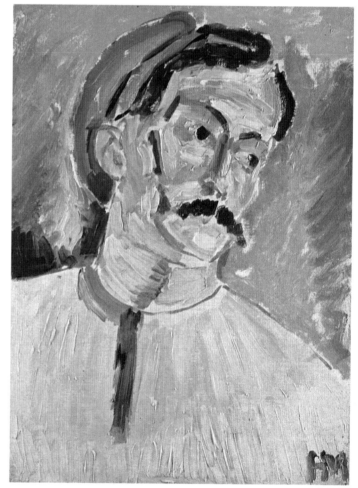

the necessity of hard work. "I don't mind telling you, it's no fun at all, but I'm staying on because here I'm compelled to buckle down to work seriously and put my heart in it. . . I've been slogging away with Matisse and I don't think he realized I possessed a science of color like the one contained in the manuscript I read you. He's going through a crisis just now, in connection with painting. But on the other hand he's a much more extraordinary fellow than I would have thought, where logic and psychological speculations are concerned. From today only dates my cure." Planning to return to Chatou in September, he announced that he would be bringing with him "about thirty studies," more "complex" than his previous attempts and "quite different" from them. He summed up the results of his summer at Collioure in two essential points:

"1. A new conception of light consisting in this: the negation of shadows. Light here is very strong, shadows very faint. Every shadow is a whole world of clarity and luminosity which contrasts with sunlight: what is known as reflections.

"Both of us, so far, have overlooked this, and in the future, where composition is concerned, it will make for a renewal of expression.

"2. Noted, when working with Matisse, that I must eradicate everything that the division of tones involves. He goes on, but I've had my fill of it completely and hardly ever use it now. It's logical enough in a luminous, harmonious picture. But it only injures things that owe their expression to deliberate disharmonies."

Derain's sunny paintings, including many views of the bay from the heights, show how rapidly he assimilated the procedures of Cross and Signac and developed them on lines of his own. He used a mixed technique, combining flat, unmodelled planes with scattered patches of shimmering color which punctuate the fluid expanse of the canvas, whose white ground is often allowed to show through. The misty colors of the Impressionists are dissolved in a limpid, shadowless iridescence. In lightly skimming touches, spaced out or speeded up as the case may be, his brush sweeps over the canvas. His color schemes are bright and florid, greatly varied in their intensity and nuances, with cool tones of violet, green and blue, and warm tones of orange, vermilion and pink. Less abrupt, less abbreviated than in his Chatou paintings, and stemming now directly from color, his line flashes out in sharp bursts, is drawn out into taut filaments, gyrates in writhing spirals, lapses into convulsive curves, as in *The Mountains*, where the olive trees in the foreground, though with much less nervous tension, recall similar motifs in Van Gogh's Saint-Rémy landscapes. Derain combined elegance with ease and power, and in spite of his youthful ebullience retained a high degree of detachment.

More organic and deep-seated, the "crisis" Matisse was going through led him to pursue, stage by stage, a radical change of style. He struggled to overcome "the tyranny of divisionism," whose overall luminosity cancelled itself out, leaving no

room for either dissonances or saturated coloring. Delighted with the climate, rejuvenated by the presence of Derain, regaining the exhilaration of his stays at Corsica and Toulouse in 1898, Matisse dashed off sketch after sketch, small riotously colored landscape studies, a few still lifes, and some open-air figure studies. Crisscrossed with hatchings, streaked with vivid colors, his canvases vibrate with a Pointillism that reaches new heights of chromatic intensity. In his sketches and jottings made directly from nature he kept for some time to this exuberant mingling of techniques inspired by Cross and Van Gogh; but it failed to satisfy his craving for harmony or to provide the solution of his problem: how to build with pure colors handled for their own sake, independently of nature.

Then, unexpectedly but in the nick of time, Gauguin's influence intervened. This happened as follows. Through a local painter, Etienne Terrus, Matisse and Derain made the acquaintance of Maillol, who lived at Banyuls, only a few miles down the coast from Collioure. Maillol had begun as a painter and was just beginning to take up sculpture; he carried on the decorative tradition of Pont-Aven and the Nabis, and designed tapestries which were woven by his wife and colored with local herbs. He opened their eyes to the almost Hellenic beauty of an Arcadian region where the gods of fable seemed to linger on in an eternal *Golden Age* (title of a large composition painted that summer by Derain, while Matisse sketched out his *Joy of Life*). A personal friend and great admirer of Gauguin, Maillol took them to the neighboring village of Corneilla-de-Conflent, where a large collection of the magnificent Tahitian canvases was stored in the home of Daniel de Monfreid, Gauguin's faithful companion. Then completely unknown, these works were a decisive revelation for Matisse and Derain, and in time for all the Fauves. Gauguin's fundamental lesson lay in the use he made of flat tracts of pure color, which overcame "the diffusion of local tones in light" by substituting for light its sole equivalent, "a harmony of intensely colored surfaces."

The last of Matisse's Collioure paintings moved rapidly toward that "excited handling of color" by which we have defined Fauvism. They are distinguished by an unprecedented (though only transitory) mixture of Pointillism and flat colors. The most characteristic example is *The Open Window*, one of the favorite motifs not only of Matisse but of all contemporary art. The brushwork, deft and fluid, is as free as in a watercolor. Painted in flat, unbroken color, the uprights of the window and the wall space on either side (blue-green and violet-red, seen against the light) form a calm, massive frame around the central opening through which the port can be seen, bathed in sunlight and dappled with dancing motes of vivid color. Certain colors go to intensify the local tone, like the green of the ivy, the red of the flower pots; others are artificially elaborated. Broken gleams of light —"that melodious side of nature," as Matisse called it—playing over the water are

also reflected in the window panes. Though depth is drastically reduced in order to leave the field free for color, there are traces of aerial and even linear perspective, of vanishing lines and accents of color crowded together in the foreground and spaced out in the background. But far from detracting from the picture, this technical disparity creates a fresh, bubbling lyricism that is absolutely new.

Back in Paris, still in the throes of his inspiration, Matisse tackled a large figure painting and within a few days turned out a bold, spirited canvas: *Woman with a Hat*. This is a portrait of Madame Matisse, seated, seen in side view as she glances toward the spectator, with her gloved arm resting on the back of the chair, wearing a huge hat in the fashion of the day—a trite enough theme, common to all the painters of 1900. But here it gives rise to a fantastic riot of colors, culminating in the monumental violet headdress, a mass of multicolored plumes encircling the cobalt-blue and brick-red hair, and crowning a face mottled with green, pink and yellow. Matisse painted many fanciful hats which, as often as not, he made up himself on the spur of the moment for his models; none is quite so flamboyant as this one. The dress is splashed with the same gaudy colors, which lap over the figure and ripple over the background. There is no longer any hierarchy of motifs; figure and accessories stand on an equal footing, developed for their own sakes and integrated into a coherent rhythm. For all its liquid fluidity, color is kept under control and, beneath a pattern of gorgeous hues, the character and individuality of the model are all the more strongly brought out, while the face looks toward us with the obsessive gaze of a Fayum portrait or an El Greco.

Having fully assimilated the tradition of Western painting, Matisse turned toward Byzantium and into the deeper bypaths of color. A youthful venture for most of his friends, Fauvism for him marked the terminal point of an initial stage of development and the beginning of a new orientation.

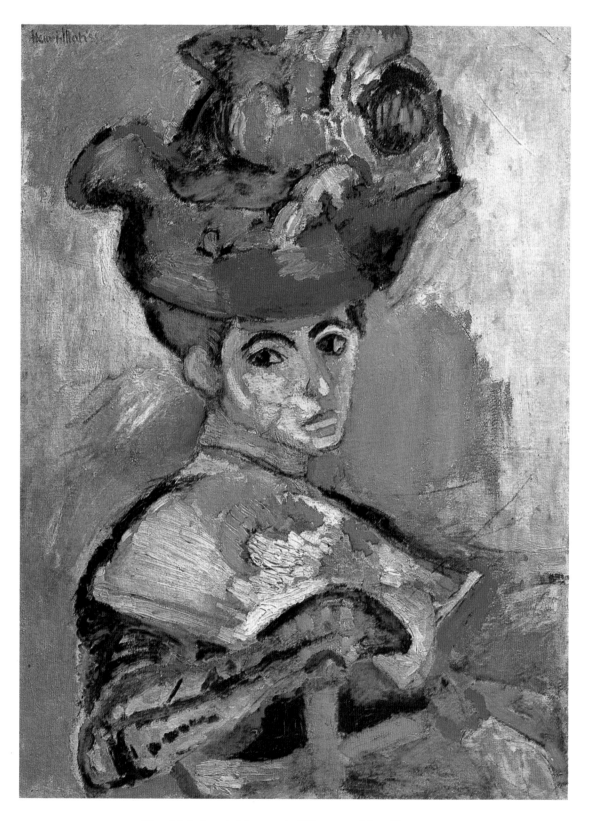

Henri Matisse (1869-1954): Woman with a Hat, 1905.

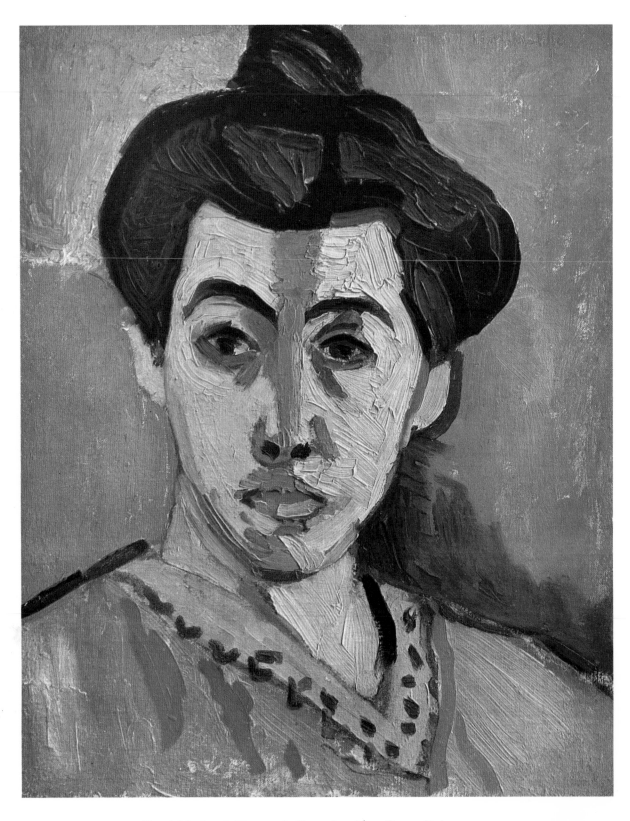

Henri Matisse (1869-1954): Portrait with a Green Stripe, 1905.

THE CLIMAX

LATE in 1905, a few months after the *Woman with a Hat*, came a second portrait of Madame Matisse, reduced now to the head and shoulders, without accessories, monumental in effect though of smaller dimensions. This work is known as *Portrait with a Green Stripe*. It owes its name to the vertical streak of yellowish green which, beneath the mass of dark blue hair rimmed and interwoven with black, divides the face into two halves—one pink, edged with orange and red, in full light, the other ochre with a green contour, in half light. This bold green median line dividing the blue eyebrows gives the face its lighting and relief, and at the same time prevents it from being submerged by the no less emphatically colored background, with its resonant contrast of violet and vermilion on one side and emerald green on the other.

It is worth while pausing for a moment over the chromatic technique of the *Portrait with a Green Stripe*, which represents a landmark in Matisse's development. Instead of fusing as before into clusters of vagrant motes flickering across the canvas in the impressionist manner, colors are assembled in compact, well-defined zones, in the manner of Van Gogh and Gauguin, but are even more strident than theirs and more constructive. Arranged in flat areas enlivened with sober accents, they tear from the human face its "mask of lofty gravity" and create a harmony of clashing dissonances whose intensity stems from the purity of the component elements and the simplicity of their tension. Surpassing all his previous achievements and even doing violence, instinctively, to the principle of complementaries, Matisse struck down to the very essence of colors, and from them sprang the vitality of his style. "Fauvism," he later wrote, "enabled me to test out my resources. My idea was to place blue, red and green side by side and assemble them in an expressive, constructive way. It was the outcome of an inner compulsion growing more and more insistent, of a deliberate decision."

The Open Window and above all *Woman with a Hat*, easily the most spectacular canvases shown at the famous 1905 Salon d'Automne, dumbfounded the critics, enraged the public, and branded Matisse as the ringleader of an art revolution. The November 4 issue of a popular Paris weekly, *L'Illustration*, reproduced both of them prominently on a special page featuring what the editor regarded as the most preposterous exhibits, among them pictures by Rouault, Derain, Puy, Valtat and Manguin. But not Vlaminck, odd as it may seem, for he exhibited mostly early works, tamer, less aggressive than his latest pictures, which included dynamic riverscapes along the Seine and suburban landscapes as well as a series of nudes and prostitutes roughly blocked out and splashed with garish colors like the wooden "Aunt Sallys" at country fairs. Already on friendly terms with Apollinaire, Picasso and the Bateau-Lavoir group in Montmartre, Vlaminck was one of the first, just about this time, to launch the vogue for Negro sculpture.

As for the other Fauves participating in the 1905 Salon d'Automne, Marquet, Camoin, Manguin and Valtat exhibited a colorful array of canvases painted in the South of France where all of them had spent the summer. The only one still to hold aloof from the lure of the south was Jean Puy, who had gone on working in Brittany. Though converted to Fauvism the previous spring at the sight of Matisse's *Luxe, calme et volupté* at the Indépendants, Raoul Dufy abstained from the 1905 Salon d'Automne, but he took part in the group exhibition in November at Berthe Weill's, where the Fauves again turned out in full force. The art historian Elie Faure now came forward with a project for decorating the Hôpital de la Charité, which, unfortunately, never materialized, thus depriving us of what would have been an irreplaceable collective testimony of early Fauvism.

On March 19, 1906, Matisse's second one-man show opened at Druet's (where Marquet and Van Dongen also exhibited), and though it comprised an important selection of forty-five paintings, together with watercolors, sculptures and a new series of lithographs and woodcuts, it was eclipsed the very next day by the opening of the Salon des Indépendants, where *The Joy of Life* overshadowed all other exhibits and established Matisse, without a rival, as the "King of the Fauves."

The Fauves were greeted by a chorus of mockery and insult as virulent, by all accounts, as the clamor that went up when the Impressionists first exhibited their work in 1874. Three reviews of the 1905 Salon d'Automne, however, are worth noting. An article by André Gide (*Gazette des Beaux-Arts*, December), though non-committal, is interesting for the personality of the author, whose narcissism, sensuality and sun-worship, taken together with the prevailing themes of his writings and the alternate forays and evasions of his career from *Urien* to *Thésée*, provide some striking parallels to the evolution of Matisse's art. Louis Vauxcelles, who from the outset had watched the progress of the young innovators attentively

and approvingly, now coined his famous epithet (*Gil Blas*, October 17). The third review of note was one by Maurice Denis (*L'Ermitage*, November 15), a leading painter of the Nabi group and an influential theorist and art critic. Though he mistakenly suspected Matisse of applying an "excess of theory," Denis perceived, in a remarkable flash of insight, the essential purity and freedom of his painting and, beneath its seeming extravagance, the underlying significance of Matisse's intentions. "This," he wrote, "is painting above and beyond contingencies, painting for its own sake, the pure act of painting. All the qualities of the picture other than contrasts of line and color, everything which the thinking mind of the painter has no control over, everything which springs from our instinct and from nature, lastly all the factors of representation and feeling—all this is excluded from the work of art. Here, in a word, is a quest for the absolute." The final step in this direction was soon to be taken by abstract painting.

In 1906 Braque joined the group and in the course of the year the Fauves spurred each other on to some of their finest achievements, while a keen interest in the movement developed abroad. This was Fauvism's hour of triumph and expansion. Now at last, after years of penury and the inevitable struggle for recognition, the Fauves found their pictures fetching good prices. Marquet signed a contract with Druet in 1905. Vollard, who had hitherto patronized only Valtat and Camoin, signed contracts with Derain in February 1905, with Puy a few months later, with Vlaminck in April 1906, acting in each case on the advice of Matisse. It was Matisse too who, in 1908, introduced the Russian collector Sergei Shchukin to Picasso. Before taking a studio of his own in the Rue Tourlaque at Montmartre, Derain was a regular visitor to the Bateau-Lavoir, where Van Dongen, another convert to Fauvism, was one of the earliest tenants. Vlaminck settled with his family in a comfortable suburban home at Rueil; now that he no longer had to depend on his violin for a livelihood, he could devote himself to painting.

Though he did not enter into a regular contract till 1909 (when he signed an agreement with the Bernheim-Jeune Gallery), Matisse was already being patronized by a select group of collectors: Marcel Sembat in France, Hans Purrmann from Germany, the Steins from the United States. In 1905 (as she relates in the *Autobiography of Alice B. Toklas*) Gertrude Stein and her brother Leo bought the *Woman with a Hat*, while Michael and Sarah Stein bought the *Portrait with a Green Stripe*. From now on Matisse was welcomed and made much of by both couples in their apartments in the Rue de Fleurus and the Rue Madame, where impressive collections of his painting could soon be seen, and where open house was kept to a carefree cosmopolitan élite, half bourgeois, half Bohemian. There, late in 1906, Matisse made the acquaintance of his young rival Picasso, the Steins at that time being the only collectors to recognize the genius of both artists.

Promptly bought by Leo Stein and now owned by the Barnes Foundation at Merion, Pa., this large composition summed up and systematized the previous summer's work at Collioure, just as *Luxe, calme et volupté* had synthesized his efforts at Saint-Tropez. Worked out in the same way, following the example of Seurat, on the basis of fragmentary studies and full-scale preliminary sketches, *The Joy of Life* was painted in the disused Couvent des Oiseaux, Rue de Sèvres, Paris, where Matisse and Friesz set up their studios late in 1905 (when the convent was vacated after the separation of Church and State). A stunning synthesis of the two classically opposed themes of Bacchanal and Pastoral, the picture glorifies both rhythm and melody, Dionysiac revelry and Apollonian serenity, the complementary beauties of arabesque and pure tone which, exquisitely harmonized, without regard for representational naturalism, organize their own musical space.

Here Matisse overcame the traditional dualism of Western painting which, treating them separately, assigns an intellectual power to line and emotive power to color. Considering art as the sign language of both the outer and the inner world, he finally attuned his work, after a long period of intense self-discipline, to the serene abstractions of Oriental art, to which Mallarmé too had constantly aspired. Suffused though it is with memories of Giorgione and Poussin, with the larger presence of Gauguin looming in the background, the picture bears witness to the predominant influence of Ingres, that "Chinaman astray in Athens," whom the 1907 Salon d'Automne honored with a large retrospective. We have Jean Puy's word for it, moreover, that when in 1907, to the consternation of die-hard reactionaries, Manet's *Olympia* was hung in the Louvre alongside the *Odalisque* of Ingres, Matisse expressed his preference for the latter.

In spite of its rather overstudied harmony, *The Joy of Life* dazzled and fascinated all who saw it—"a bracing sense of elation," noted Vauxcelles. Preceding Picasso's *Demoiselles d'Avignon* by well over a year, it stands out as the first masterwork of twentieth-century painting. The very embodiment of Fauvism, at the same time it transcends Fauvism and contains in embryo the later achievements of Matisse, who all his life continued to draw on this source, just as Rodin drew on his *Gate of Hell*. It is the glorious emblem of an œuvre whose Olympian serenity is the triumph of art over the absurdities and anxieties of life. In his stimulating study of Fauvism, which is first and foremost a passionate hymn to Matisse, Georges Duthuit puts his finger on this paradox of the creative act, torn as the artist is between easy freedom and rankling uncertainty.

After the *vernissage* of his exhibition at Druet's in March 1906, followed by the opening of the Salon des Indépendants, Matisse made the first of his many trips to North Africa, where he delighted in the sun and admired Islamic art, whose stylizations and fresh colors had already pervaded his *Joy of Life*. He stayed two

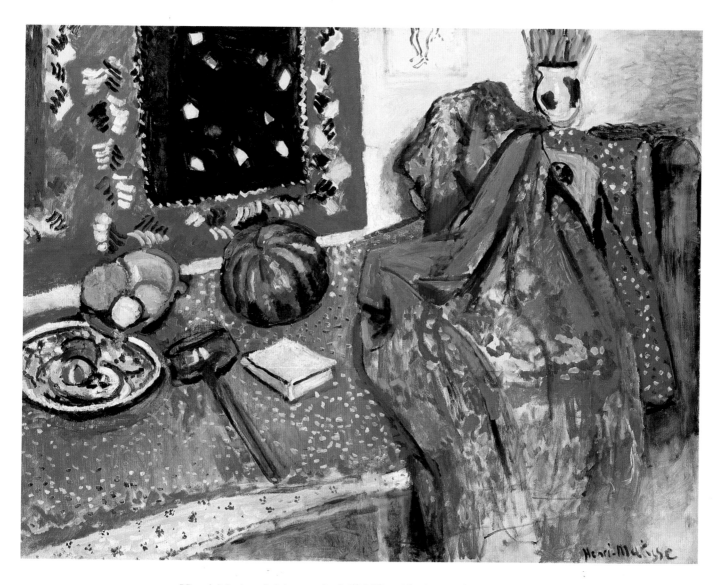

Henri Matisse (1869-1954): Still Life with Oriental Rugs, 1906.

weeks at Biskra, in Algeria, where he bought the Arab pottery and textiles that were soon to figure in his pictures, and returning to France went directly to Collioure, where he spent the rest of the summer. There he worked harder than ever at a long series of landscapes, still lifes and figure paintings, branching out in several directions, now toward massive, architecturally ordered forms bound in thick contours, now toward thin, decorative tracts of color devoid of outlines or edged with graceful arabesques.

Fauvism for Matisse was nothing more nor less than just such freely varied experimentation as this with color and line, which in his hands yield a maximum

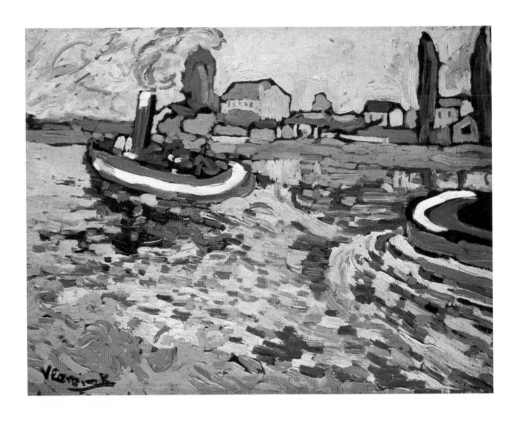

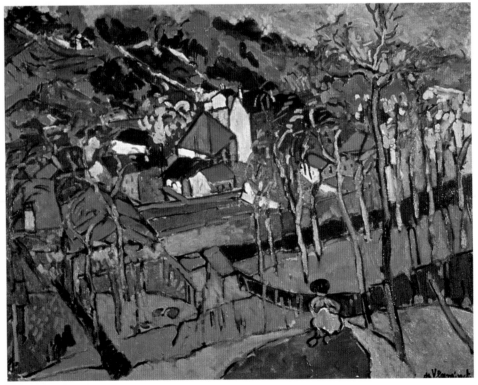

Maurice Vlaminck (1876-1958)
Tugboat at Chatou, 1906.
The Village, 1906.

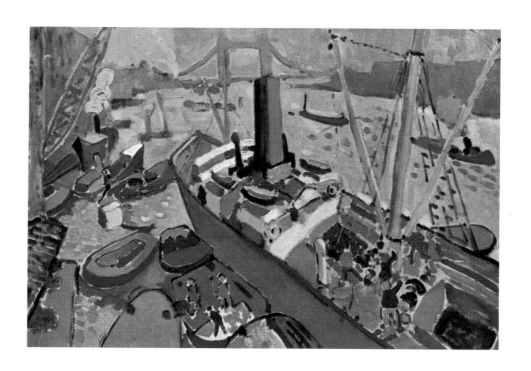

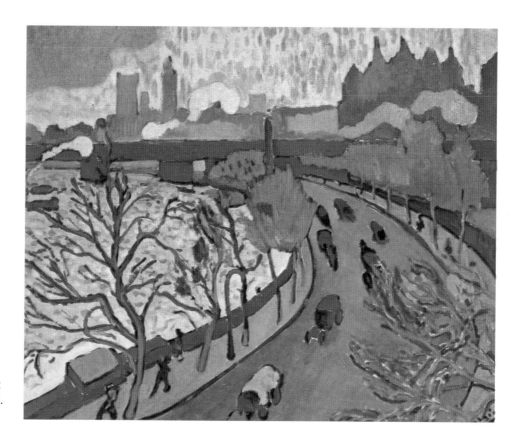

André Derain (1880–1954):
The Pool of London, 1906.
Westminster Bridge, 1906.

of concision and expression. His landscapes include hasty pointillist sketches, synthetic views of Collioure, sometimes vigorously mottled, sometimes suspended in quiet pools of unmodelled blues and pinks. His attention centered now on the human figure which, he said, echoing Van Gogh's conviction, "best enables me to express the virtually religious feeling that life inspires in me." He painted the two closely related versions of *The Young Sailor*, one still somber and uneasy, the other limpid, supple, almost oriental in its ease and freedom; several studies of his daughter, notably *Marguerite Reading*, in a red dress with polka dots, her hands shaded in green; and his monumental *Self-Portrait*, tense and imposing, hieratic as an icon.

Three significant still lifes display not only the richness of his style but its free-ranging development, unimpeded by systems or formulas. The small *Still Life with a Plaster Figure*, with its muted colors and tonal atmosphere, marks a curious regression. *Still Life with Pink Onions*, on the other hand, bold and naïve as a child's watercolor, is laid out against four juxtaposed zones of bright color, separated now not by contours but by thin margins formed by the white ground of the canvas left unpainted. *Oriental Rugs*, which Matisse regarded as his finest still life, combines a variety of procedures (pointillist dottings, patches of flat color, heavy outlines, transparencies, vibrations); even browns and blacks are worked into its gorgeous color scheme. The first to use pure tones, Matisse was also the first to revert to shading, and this at the height of Fauvism; he was the only one, moreover, who was able to tone down his colors without diminishing their luminosity. For the radiance of colors springs not so much from their intensity on the palette as from the manner of their arrangement on the canvas, from their juxtapositions and setting.

Vlaminck, on the contrary, went on pressing his colors from the tube straight on to the canvas—colors as pure and shrill as he could make them. After the unexpected windfall of April 1906, when Vollard bought up the contents of his studio *en bloc* and signed a contract with him, Vlaminck felt that he had arrived. His exuberance knew no bounds and the summer of 1906 was undoubtedly the happiest, most fruitful period of his whole career. Working daily along the Seine in the immediate vicinity of Chatou, he sometimes set up his easel, like Monet, in full view of the river, with the sun flashing on the water, with factories in the background crowding toward the riverbank, with a tugboat towing barges up the Seine; sometimes, like Pissarro, overlooking the Seine valley, with houses and rooftops dotted among the trees on the hillside. We find him in the heat of action, bringing off one of his most characteristic Fauve paintings, in *The Village*. "I used to go to work right out in the sunshine; the sky was blue, the wheatfields seemed to be stirring and trembling in the torrid heat, with hues of yellow covering the

whole scale of chromes; they quivered as if they were about to go up in flames. Vermilion alone could render the brilliant red of the roof tiles on the hillside across the river. The orange of the soil, the raw, harsh colors of walls and grass, the ultramarine and cobalt of the sky, harmonized to extravagance at a sensual, musical pitch. Only the colors on my canvas, orchestrated to the limit of their power and resonance, could render the color emotions of that landscape.''

This makes it abundantly clear that Vlaminck's approach was still naturalistic. He aimed not so much at transposing the scene before him as recasting it excitedly by simplifying its structure and overstressing local tones. The dark, heavily pigmented contours which had hitherto divided his canvases into effervescent zones were now broken up into discontinuous, multicolored segments, or else disappeared altogether in an uprush of tumultuous colors. Forms spring to life now in cymbal-clashes of pure tones, blood red, sunny yellows and oranges, sweltering blues pitched to the top of their bent and unified in dynamic, imperious harmonies. He used a full brush, steeped in light and plied with obvious relish, though on occasion he could linger over delicate shades of expression. The slave of his moods and temperament, Vlaminck was carried to the heights by the very driving force that in time betrayed the shortcomings of his vision, which lacked the spice of variety. He was content to record violent sensations extempore, with rampageous gusto or a petulant show of anguished feeling. His style was founded on blind confidence in the subjectivity of his gifts and the immutable reality of nature. It was founded, in other words, on a contradiction, for even the finest gifts soon come to grief unless quickened by the restless searchings of the mind. Nature, for the painter, is not a reality but an incessant creation. Pure colors and lusty sensations are not enough, there has to be a filtering and transmutation of sensory data. Vlaminck loudly proclaimed painting to be a "way of being," but just as there is no existence without growth, so there is no true style without evolution.

Since working with Matisse at Collioure in 1905, Derain had been moving away from the rudimentary color sensuality of Vlaminck toward more refined and subtle equivalents of emotional experience. "We've got to get out of the rut in which realism has landed us," he wrote from London, to Vlaminck appropriately enough, on March 7, 1906. This visit to London, whose atmosphere delighted him, produced the finest work of Derain's Fauve period: some twenty views painted at the request of Vollard, who exhibited them as a sequel, very different in style and spirit, to Monet's famous views of the Thames which met with so great a success at Vollard's gallery in May and June 1904. Monet, with his serializing methods, chose three motifs (Waterloo Bridge, Charing Cross Bridge and the Houses of Parliament) which he reinterpreted again and again at different times of day. This approach was altogether foreign to Derain; he admired Monet "even

for his errors, which taught me a valuable lesson," but his concern was with "everything that, on the contrary, is fixed, immutable, complex."

Just as he had done along the Seine at Chatou, so Derain worked now along the Thames embankment, from the Houses of Parliament down to Greenwich, and also painted a few views of Hyde Park and Regent Street. To judge by differences of technique and seasonal variations of light, Derain's London pictures were painted in the course of several visits which, in the absence of documentary evidence, are usually dated between 1905 and 1907. The latter year, however, can safely be ruled out, while his recorded activities of 1905 leave very little room for a trip to England. The most that can be said is that he was in London in the spring of 1906, in March and April for certain, and presumably came back in the autumn, which would account for the stylistic changes in this series of views and would also coincide with his evolution. Derain's London pictures represent an important stage of Fauvism, so it is worth while pausing over them and noting their sequence.

The first are lyrical views of the Thames, with the jagged silhouette of the Houses of Parliament and rhapsodic effects of sunrise and sunset; these are inspired by Monet and Turner, though they often keep to the pointillist technique of Collioure. While Vlaminck was exulting in warm, pure tones of vermilion and chrome yellow, violently clashing with cobalt and ultramarine blue, Derain took to flexible, aerial color schemes dominated by cool shades of green, violet and blue tinged with pink and lilac, permeated with the characteristic atmosphere of London. What he was after, he wrote, was "forms born of the open air, of broad daylight, and made to reveal themselves in broad daylight"—not in vaporous diffusion after the manner of Monet, but in all their glistening density as they come to life on the colored surface of the canvas.

While going to the brink of abstraction (but no further), Derain explored all the decorative possibilities of color, expressive color used with an eye to transfiguring reality. Painted at one go in April 1906, *The Pool of London* is the best example of a new series of canvases, more complex and brilliant in texture, disengaged now from the influence of either Monet or Turner and depicting the full sweep of the Thames with its picturesque animation. "The Thames is immense," exclaimed Derain, "it is the reverse of Marseilles. I need say no more." By now, as these pictures show, Fauvism was a self-sufficient color idiom, independent of the motif.

In leisurely views of *Hyde Park* and buoyant glimpses of *Regent Street* Derain's line deftly responds to the moods of the color scheme. At one moment staccato linework, similar to Marquet's, evokes the swarming multiformity of street crowds and traffic under a mauve English sky; at another, thin graceful strokes spin out a pattern of branches or skip along the edge of lawns and walks formed by smooth flat tints of green and pink, elegant to a degree and picked out with scarlet and azure

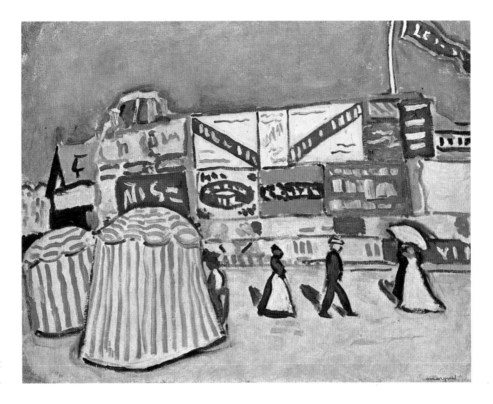

Albert Marquet (1875-1947):
Posters at Trouville, 1906.

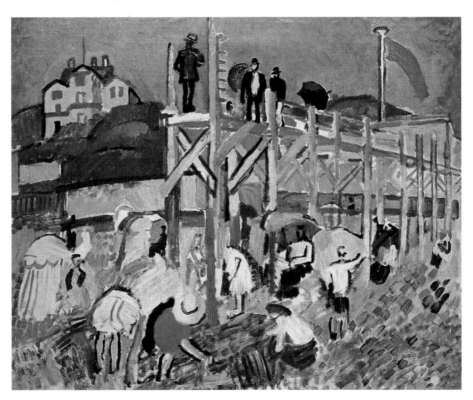

Raoul Dufy (1877-1953):
Sainte-Adresse, The Jetty, 1906.

Othon Friesz (1879-1949): The Port of Antwerp, 1906.

blue. In *Blackfriars Bridge* outlines are thickened in order to support so sturdy a structure, with its dense, high-pitched colors. Chosen for the 1906 Salon d'Automne out of all his London pictures, whose finest qualities it exemplifies, *Westminster Bridge* is one of the unqualified masterpieces of Fauvism. Pure tones of yellow, green, blue and pink are poured freely over the canvas and channelled by patterned curves whose dynamism sweeps up and unifies every element of the composition. What Derain achieves here is a masterly fusion of Lautrec and Gauguin. In addition to the fascination of its street and river scenes, London offered Derain the inexhaustible wealth of its great museums of art and ethnography, to which, as we learn from his letters, he was an assiduous visitor. He must have communicated his enthusiasm to his friends, for trips to London were made in 1907 by Marquet, Friesz and Camoin, in 1911 by Vlaminck.

After his sudden conversion to Fauvism, Dufy remained in close touch with his old friends from Le Havre, working on the Channel coast with Friesz at Falaise in 1905 and 1906, and with Braque at Durtal in 1906. But he had become

Georges Braque (1882-1963): The Port of Antwerp, 1906.

particularly friendly with Marquet, with whom he shared a great admiration for Claude Lorrain. Working from nature, they painted side by side at Fécamp in 1904, at Sainte-Adresse in 1905, and in 1906 they spent the summer together along the Channel coast, in the triangular stretch of Normandy formed by Le Havre, Honfleur and Trouville—the old haunts of Monet, Boudin, Jongkind and so many others. At Trouville they painted the same billboard covered with gaily colored posters, at Sainte-Adresse the same seaside pier, at Le Havre the same bird's-eye view of the harbor, the same streets bedecked with flags and streamers for the 14th of July. Both of them freshened up their palettes and both made several versions of these common themes.

A comparison of their treatment of them shows a great similarity of technique, a fondness for the same colors, a similar dexterity in the handling of line and color patches. But there are also plenty of differences: a lighter, more playful, more fanciful touch in Dufy's work, more character and bolder simplifications in Marquet's. The latter is seen at his best in *Posters at Trouville*, with its firm design

and resilient linear tension; less numerous than in similar versions by Dufy, details and figures are discreetly subordinated in order to bring out the full decorative value of the beach tents, with their curving stripes, and the advertising posters, emphatically blocked out in flat colors. Dufy, always captivated by the picturesque and lively, by brightly dressed holiday crowds, never wearied of beach scenes. As early as 1902, under Boudin's influence, he had painted the boardwalk at Sainte-Adresse, in front of the Casino Marie-Christine, seen from various angles and enlivened with a steady stream of strollers. And it was at Sainte-Adresse, Dufy later told Pierre Courthion, that he made the momentous transition from outward imitation to inner transposition. Examining his brushes and color tubes one day, he asked himself: "How, with these, to render not what I see, but what is, what exists for me, *my reality*? That is the question. The answer to it lies in my hands and nowhere else." His 1906 versions of the boardwalk at Sainte-Adresse show that he had already found the answer, at least in part; they reveal his mastery of accurate formal structure, his bold but always graceful handling of color.

All the colors of their palettes were let loose in honor of the 14th of July, the French national holiday, whose flags and bunting became now the emblem of Fauvism. The Union Jack and Tricolor float side by side in the wind over the sunny breakwater of Le Havre, painted simultaneously by Marquet and Dufy. The sequence of 14th of July pictures which opens this book shows the evolution of this characteristic theme from Monet and Van Gogh to Marquet and Dufy. Abandoning the atmospheric phantasmagoria of Impressionism, the Fauves gloried to their heart's content in high-spirited surface effects and pure, full-bodied colors ringing out like trumpet blasts.

While Marquet and Dufy were summering in Normandy in 1906, Braque, youngest of the Havre trio, was working with Friesz at Antwerp, where he now adopted Fauvism. A sailor's son and a great admirer of Rubens, Friesz felt very much at home in Antwerp, where he had also spent the summer of 1905. As Braque later destroyed most of his early efforts, his creative output (as he freely admitted) begins with the canvases he painted at Antwerp in 1906. Numbering about a dozen in all, these already display the acuteness and charm of his vision, his lyrical restraint, his fine powers of renewal and enrichment. The two men shared a studio above the Scheldt, looking down on the shifting lights of the river and the passing boats. Reproduced here are two views of the port, seen from the same vantage point: Braque's, calm and glistening, painted in a mood of dreamy contemplation, that of Friesz nervously built up in swiftly gliding strokes of the brush.

After stopping over in Paris in September and October 1906, where he painted several versions of a favorite theme of Sisley's, the *Canal Saint-Martin*, Braque paid his maiden visit to the South of France and settled at L'Estaque for the winter.

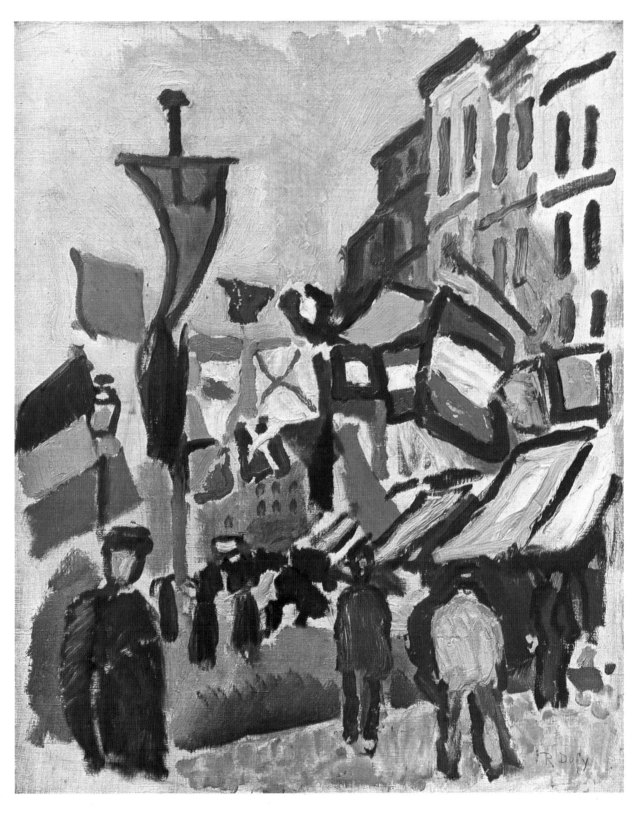

Raoul Dufy (1877-1953): The Fourteenth of July, 1907.

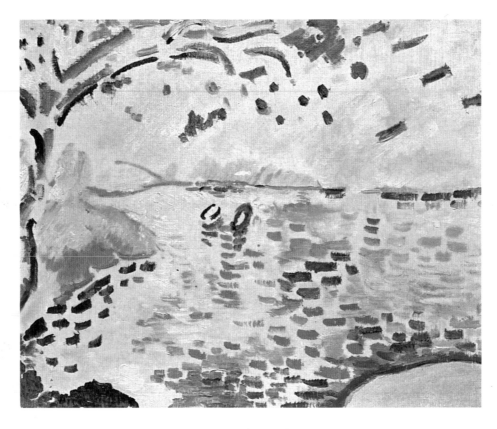

Georges Braque (1882-1963): The Little Bay at La Ciotat, 1907.

There he assimilated the pointillist technique worked out by his elders at Saint-Tropez and Collioure. At the same time, in radiant but unimpassioned color schemes, he tried out various combinations of linear rhythms and decorative surface patterns. These iridescent, gemlike paintings, marvels of Fauvism, tinted with cyclamen, orange and old-gold, combine a highly personal style with echoes of Gauguin, Matisse and Seurat.

Returning to Paris in February 1907, Braque exhibited six canvases at the Salon des Indépendants and sold them all. He now became friendly with Matisse, Derain, Vlaminck and the other Fauves. Going south again in May, he settled at La Ciotat, near Toulon, where Friesz soon joined him. Their colors blazed up radiantly, becoming constantly remoter from visual appearances; the composition of these canvases rises vertically in successive planes, circumscribed with arabesques, sinuous and kaleidoscopic in the work of Friesz, concentric and leisurely in Braque's. In September, however, when the two artists moved down the coast to L'Estaque, we find them showing a new interest in form.

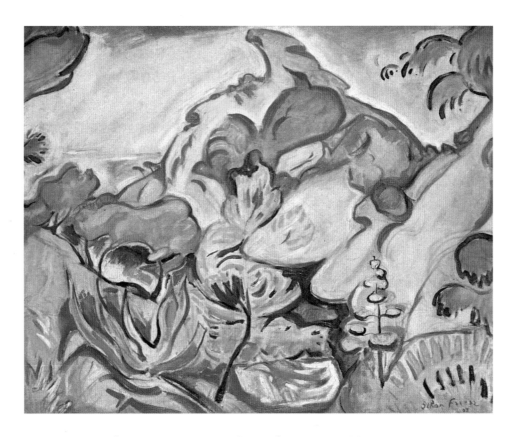

Othon Friesz (1879-1949): Landscape at La Ciotat, 1907.

In the 1906 Salon d'Automne the Fauves figured in full strength and at the top of their form. It was, as Vauxcelles admiringly observed, "a regular display of fireworks." Having traced the origins and progress of the movement, born of personal contacts and convergent aims, we can now sum up its basic principles. These are, briefly, an even distribution of light and construction of space by color; an all-over illumination of the flat surface, without illusionist modelling or shading; a fine spareness of means; a total harmony between expression (i.e. emotive values) and decoration (i.e. balanced arrangement of the picture content) achieved by composition.

"Composition," Matisse explained in his famous *Notes d'un Peintre* in *La Grande Revue* (December 1908), "is the art of arranging in a decorative manner the various elements at the painter's disposal for the expression of his feelings." Form and content coincide and are modified by their reciprocal action on each other, for "expression comes from the colored surface, perceived by the beholder in its entirety." And this global vision, if it is to retain its freshness and vitality,

Raoul Dufy (1877-1953): Vestibule with Stained-Glass Windows, 1906.

sometimes involves radical mutations of forms and colors. "There is a necessary proportion of tones," Matisse continues, "that may lead me to change the shape of a figure or transform a composition," whose initially dominant color, say green, ends up as red, or vice versa. "A new combination of colors will take the place of the first and set the key of the tonality of the representation. I am forced to transpose, and that is why people imagine my picture has completely changed when, after a series of modifications, red has replaced green as the dominant color." From this color alchemy there results "a harmony resembling that of a musical

composition," and the whole picture becomes "sensitized," its texture thus acquiring a lyrical tension answering to "a state of mind created by the objects around me, influencing me all the way from the horizon up to myself." Only thus does the painting become a living presence, open to the continuity of a space that has no gaps, no hierarchy, and to the flux of time, caught in its full flow, not crystallized in moments. "Indication of motion has meaning for us only when we do not isolate the present sensation of movement from the one preceding it and the one that follows it."

Maurice Vlaminck (1876-1958): Landscape with Red Trees, 1906-1907.

Deriving as it does from a spontaneous reaction to color ("I discover the expressive quality of colors in a purely instinctive way"), Fauvism might be described as a dynamic sensuality ("the impact a scene produces on the senses"), controlled by synthesis ("condensation of sensations") and subordinated to the basic compositional requirements of the picture. "Every part of the picture must be visible and fulfills the role assigned to it, whether a leading or a secondary role. Anything that serves no useful purpose in the picture is, for that very reason, detrimental to it." Matisse insisted on the discipline and methodical transposition

Paul Gauguin (1848-1903): Decorative Landscape, 1888.

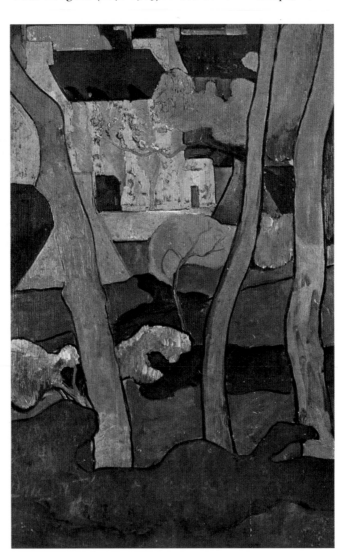

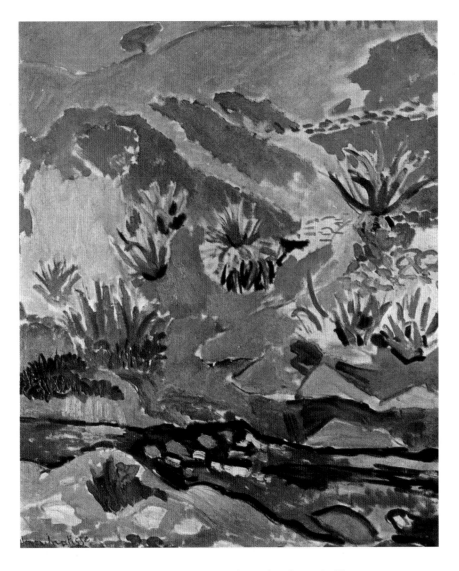

Henri Matisse (1869-1954): Brook with Aloes, Collioure, 1907.

which differentiated the genuine creators of the movement from their followers, who merely added color to a conventional scheme, behaving more like dyers than painters. The excited handling of color is not enough in itself to characterize the movement. "This was only the superficial aspect of Fauvism," Matisse explained. "The truth of the matter was that we kept at the farthest remove from imitative colors and that by using pure colors we obtained stronger reactions—simultaneous reactions, more immediately apparent. Then there was also the *luminosity* of colors."

Matisse discovered later that the principles of Fauvism set forth in his *Notes d'un Peintre* (published in December 1908) had been anticipated, if not explicitly stated, by Gauguin in *Racontars d'un rapin*, and in *Notes éparses*, the sequel to *Noa Noa*. "I noticed," wrote Gauguin, "that the play of lights and shadows by no means produced an equivalent of any natural light… What, then, would be its equivalent? Why, pure color!" His biographer Rotonchamp has recorded some prescient comments made by Gauguin even before leaving for Tahiti. "There are no gaps in nature. All tones, even shrill ones, are merged into a uniform harmony. Only in pictures are there gaps. Values are what destroy the overall harmony of tones in the picture by introducing elements foreign to color and deriving from chiaroscuro." As it so happened, the largest retrospective exhibition of Gauguin's work that had ever been brought together (227 items) was held at the Salon d'Automne of 1906. Every retrospective is as it were the public celebration of an influence that artists have already undergone. In the last analysis it is clear that the Fauves derived from Gauguin their use of pure colors applied in flat areas as the sole constructive principle of the picture: color governed by the imagination, not by reality, and

Henri Matisse (1869-1954): Blue Nude, 1907.

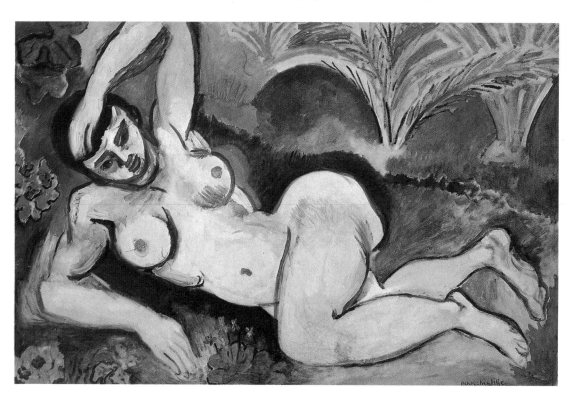

endowed with both metaphorical and space-creating powers. It was Gauguin, moreover, who rehabilitated the instinctual life which in the late nineteenth century had been stifled by the pressures of industrialization, and promoted an artistic and human understanding of primitive peoples.

In practice, however, Gauguin did not always succeed in avoiding the half-measures he denounced in theory. His hankering for sculpturesque effects and eye-pleasing volumes told against his feeling for flat surfaces and the modalities of mural painting. What is more, the prevailing vogue in the eighties and nineties for mysticism and symbolism, from which he was not always immune, led Gauguin sometimes to divert the vital potency of his color toward some vaguely conceived "mystery," into sentimental bypaths. "What prevents Gauguin from being assimilated to the Fauves," Matisse observed, "is his failure to use color for constructing space, and his use of it as a means of expressing sentiment." A comparison of any one of his mature works with corresponding works by Matisse and Derain at once reveals his significance as a pathfinder, but also reveals the extent to which his leading successors purified his handling of color. In Matisse's *Brook with Aloes*, which is "perhaps the most significant landscape of the Fauve period" (Alfred H. Barr, Jr.), the illusion of space, volume and physical texture, already greatly diminished in Gauguin's art, is completely done away with. No trace remains of the old use of color as a factor of perspective (warm tones in the foreground and cool tones reserved for the hazy blue of distance) which Impressionism had modified and Fauvism discarded altogether. Juxtaposed without contour lines, in lightly applied, luminous coats, the colors pattern the surface of the canvas, tapestry-wise, creating that pure, all-pervading harmony which Matisse described as a "spiritual space."

The 1907 retrospective exhibition at the Salon d'Automne was devoted to Cézanne, whose constructive influence now superseded the decorative trend initiated by Gauguin. This was a key year in the annals of modern art, for now Cubism made its entry on the scene, striking across the final manifestations of Fauvism and a resurgence of Expressionism. All these tendencies can be seen, controlled by a master hand, in that astounding *Blue Nude* which Matisse completed just as Picasso (with whom, significantly enough, Derain was in close contact) was giving the finishing touches to the *Demoiselles d'Avignon* and launching modern painting in a new direction.

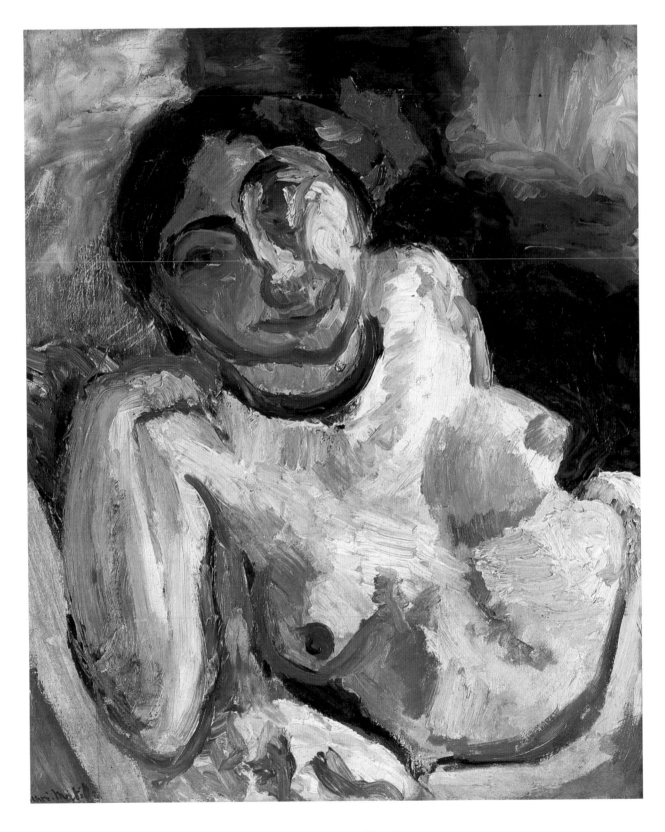

Henri Matisse (1869-1954): The Gypsy, 1906.

FAUVISM-EXPRESSIONISM

FAUVISM was not confined to France but was a Europe-wide phenomenon. It was promoted in Germany by two localized groups: Die Brücke, during its Dresden period (1905-1911), and the Neue Künstlervereinigung at Munich (1909), before its leading members seceded (in 1911) and founded the group known as Der Blaue Reiter. Since Expressionism was then the dominant art trend beyond the Rhine, and since at the same time many expressionist elements can be traced in Fauvism, the epithet Fauvism-Expressionism may serve to describe the art deriving from contacts between the initial movement in Paris and the parallel currents in Dresden and Munich.

Expressionism is not so much a systematic program as a latent disposition of the sensibility, stimulated to fever pitch in periods of social and spiritual unrest, and is symptomatic of the age we live in. Its major exponents are Nordic artists who, unlike Latin artists, tend to labor under a burden of anguish and pent-up emotions, to confuse art and life, and to set more store on "psychic force" than on "plastic form." Expressionists see the world in terms of their emotional conflicts and render it as such, without transposing it into a stable harmony.

Reacting against Impressionism and the objective fidelity to fact of Cézanne and Seurat, a first wave of Expressionism, mingled with elements of Symbolism and Art Nouveau or Modern Style (known in Germany as Jugendstil), swept over Europe in the years between 1885 and 1900, its chief exponents being Van Gogh, Lautrec, Ensor, Munch and Hodler. They gave expression to their heart-searchings by the use of themes that were at once obsessive and dramatic, and not only by stepping up color to its highest pitch but also by emotive form, a flowing or jagged linearism accompanied by a return to graphic art and the techniques of illustration.

Founder and figurehead of modern Expressionism, Van Gogh succeeded in giving it an exemplary value, due largely to the intimate association between his

life and his life's work. In several of his letters, and particularly with reference to his portraits, he explains his procedures, fearing that his willful exaggerations might suggest a caricatural intent. The popular, spontaneous form of Expressionism is, in fact, the caricature, but in Van Gogh's work it is sublimated from a travesty to a symbol, charged with religious grandeur and with something of Rembrandt's noble humanism. Lautrec too transcends the caricature, combining as he does a style of ruthless incisiveness with a deep feeling for the human; he ranks as the creator of the modern poster, dynamic synthesis of decoration and illustration. Munch, a compatriot of Ibsen with the morbidity of Kierkegaard, was the central figure of Northern Expressionism. His influence in Scandinavia and Germany is comparable—though operative in a diametrically opposite direction—to that of Cézanne in France.

A second, more massive, more violent wave of Expressionism, aggravated by the mounting tension of the years preceding the First World War, swept over Europe from 1905 onward. It began in Germany under the auspices of the Brücke group; in France with the strange new art of Rouault, with Picasso's Blue and Negro Periods, with Matisse and the Fauves.

The art group known as Die Brücke (The Bridge) was founded in 1905 by four students at the Technical Institute in Dresden: Ernst Ludwig Kirchner, Erich Heckel, Fritz Bleyl and Karl Schmidt-Rottluff. Though young and poor, all four were fired with passionate enthusiasm and a proud disdain of all conventions, social and artistic. They met sometimes in Kirchner's rooms, sometimes in a former butcher shop, in a working-class district of Dresden, which had been fitted out by Heckel to serve as their collective studio. Here, untroubled by the smug bourgeois society they so heartily loathed, they led Bohemian lives, experimented in art and practised the communal mode of living dreamt of by Van Gogh and Gauguin. They read Strindberg and Dostoevsky, Hölderlin, Walt Whitman and above all Nietzsche.

Like all truly fruitful movements, theirs had no set program. Kirchner, their guiding spirit, published in 1906 a small manifesto in the form of a woodcut; it is a vague appeal to youth to be up and doing, to give free rein to the creative impulse, to cast off the shackles of convention. In February 1906 Schmidt-Rottluff wrote to Emil Nolde, paying homage to his "storms of colors" and inviting him to join the Brücke group, whose purpose, he said, was "to incorporate all the revolutionary elements then in a state of gestation." Nolde accepted, but withdrew from the group the following year. The qualities he shared with Rouault—mystical fervor, an instinctive craving for solitude, an abundant vein of inspiration and a fierce independence—made him unable to join forces with the Brücke, just as Rouault was unable to join the Fauves. Other members were recruited in 1906:

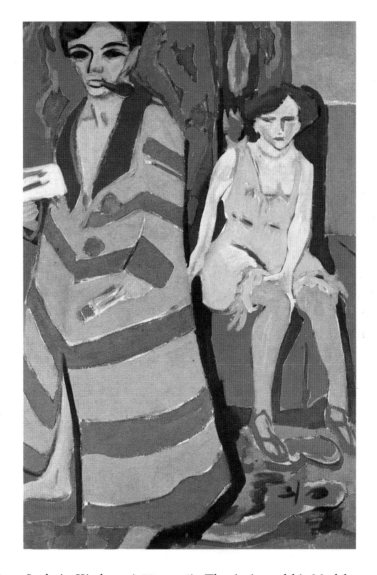

Ernst Ludwig Kirchner (1880-1938): The Artist and his Model, 1907.

Max Pechstein, the Swiss Cuno Amiet and the Finn Axel Gallen. The last member to join was Otto Mueller, in 1910.

The first two Brücke exhibitions failed to attract any attention. They were held in the spring of 1906 and the winter of 1906-1907 in the premises of a lamp and lampshade factory at Dresden-Löbtau. Passing through Dresden on his way back from Paris, Kandinsky took part in the second exhibition, devoted entirely to graphic work, and probably told the group about the parallel movement on the rise in France. The third Brücke exhibition was held in the elegant salons of the Richter Gallery in Dresden, and though it came as a shock to the few who saw

it, it again passed largely unnoticed. It fell to the Brücke group to inaugurate modern art in Germany; in order to realize how revolutionary their activities were, it must be remembered what Germany was like in those days. Social life was still rigidly channelled in accordance with a strict hierarchy of classes. As far as art was concerned, the mildly impressionist naturalism of Max Liebermann was just beginning to win recognition, while the only sign of genuine innovation was Jugendstil. A decorative art imbued with symbolism, characteristic of Berlin, Vienna and Munich in the nineties and early 1900s, Jugendstil filtered into Dresden, then the leading German center of poster design, and harmonized with the sophisticated Baroque charm of the old city. The Brücke painters exploited the linear possibilities of Jugendstil, while at the same time reacting violently against its ornamental formalism.

Their activities ranged feverishly over painting, woodcarving, woodcuts, lithography, etching, posters, and pattern printing on textiles. A strong similarity of technique and vision, made even more pronounced by their habit of working in common, characterized the early style of the group, bold and aggressive in tenor. They drew inspiration not only from Munch and the great post-impressionist masters, particularly Van Gogh, Gauguin and Lautrec, all of whom were exhibited in Germany from 1901 on (Van Gogh at Dresden in 1905), but also from the national revival of interest in Gothic expressionism (as exemplified by Grünewald) and from the Negro and Polynesian carving discovered by Kirchner at the Zwinger Museum of Ethnology in Dresden in 1904. They used pure, high-pitched colors dramatically, binding them into broad, dynamic surfaces with taut contour lines. The nervous angularity of their linework is due to their predilection for graphic art (woodcuts, lithography, etching), which they published periodically in albums. Some of their finest work was done in the field of the woodcut, especially the color woodcut, which called for the drastic simplifications and expressive transpositions in which they excelled. Revived and rehabilitated late in the nineteenth century by Gauguin, Munch and Vallotton, the woodcut was now as popular among painters as lithography had been in the days of Romanticism; its vogue in Germany, moreover, was solidly founded on a tradition going back to Dürer, whose woodcuts Kirchner had studied at Nuremberg as early as 1898.

Slightly older than his companions, a strong personality but nervous and high-strung, Kirchner stands out as the leader of the Brücke group. Eager to express himself articulately and (in his own words) to reinvigorate the art of his country, he cultivated every means of expression within his ken and assimilated the most tonic influences of contemporary, medieval and primitive art. During a stay in Munich in 1903-1904, a study of Rembrandt's drawings in the print room of the Alte Pinakothek taught Kirchner to jot down forms in movement and to make

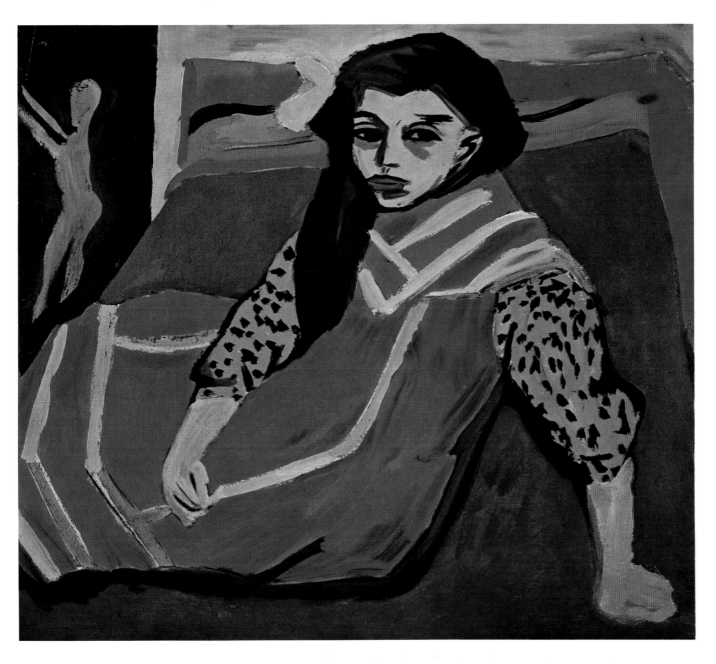

Ernst Ludwig Kirchner (1880-1938): Woman on a Blue Divan, 1907.

the most of line by sketching rapidly from the life, while a neo-impressionist exhibition sponsored by the Phalanx (a group over which Kandinsky presided) oriented him at the same time toward problems of color. In Dresden, in 1904, the sudden revelation of Negro and Polynesian art speeded up his evolution. As early as 1907 his powerful originality was displayed not only in the drawings and

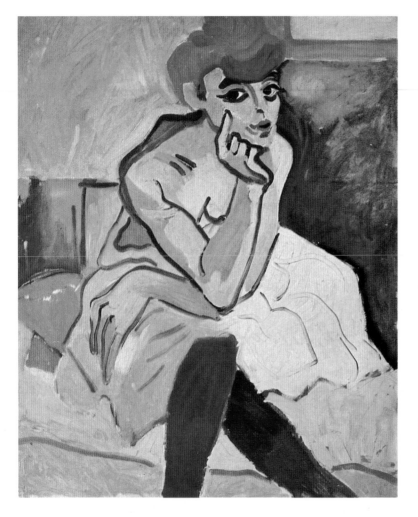 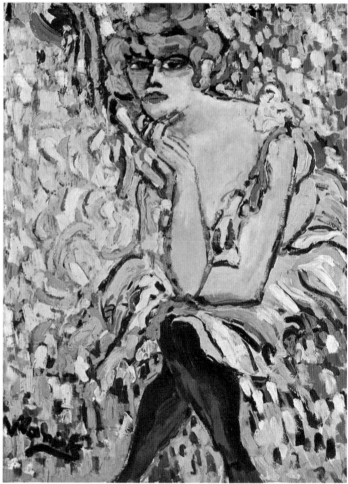

André Derain (1880-1954):
Dancer at the "Rat Mort" (Woman in a Chemise), 1906.

Maurice Vlaminck (1876-1958):
Dancer at the "Rat Mort," 1906.

engravings which at first constituted the chief activity of the Brücke group (and Kirchner's graphic work, be it noted, is probably the most extensive of the twentieth century, even exceeding that of Munch and rivalling that of Picasso), but also in some remarkable paintings, like *The Street* and *The Artist and his Model*. The frontality and forward thrust of the figures are combined in varying degrees with the phantasmal atmosphere of Munch, the fluid sinuosities of Jugendstil, and the incisive accents of Lautrec. Planes of bright color are rhythmically coordinated. *The Artist and his Model* is laid out within a strictly confined picture space whose two-dimensional surface is emphasized by the red curtain on the left and the pink rectangle on the right; the painter, in an orange dressing gown with blue stripes,

looms large in the foreground, his model is seated behind him on a crimson divan. The tense atmosphere and hard egocentric gaze of both are typical of expressionist art.

Other outstanding canvases by Kirchner, for example *Variety* and the famous *Woman on a Blue Divan*, which is often assigned to 1907, were, it seems, deliberately antedated by the artist himself in order to make it appear that they synchronized with Fauve art. There was, anyhow, no direct link between the Brücke group and the Fauves until Max Pechstein returned to Dresden late in 1907 from a trip to Italy and France. In Italy Pechstein was deeply impressed by Giotto (so was Matisse at exactly the same time), the Primitives, and the Etruscans. In Paris Pechstein saw the work of the Fauves and made the acquaintance of Van Dongen. Invited to exhibit with the Brücke at Dresden in 1908, the latter cordially accepted and sent in some watercolors and drawings.

The fact that Van Dongen was a Dutchman was naturally reflected to some extent in his themes, technique and vision; he stood as it were midway between the French and German groups and thus formed the vital link between them. He exhibited with the Fauves, but following in the footsteps of Lautrec he haunted the streets and night spots of Montmartre, sketching clowns, dancers, chorus girls and prostitutes. Art for him (for the time being) was inseparable from the life he found there, from its glitter and sensuality. "I exteriorize my desires by recording them in pictures. I love everything that glitters, precious stones that sparkle, silk and satin that glisten, beautiful women who awaken carnal desire… Painting gives me a more complete possession of all this." No investigator of space but a fine colorist and a virtuoso in the handling of line, Van Dongen delighted in rich textural effects. His strident harmonies are sometimes reminiscent of Pechstein and Kirchner, but he handles flat color more freely and easily and shows a more sensitive response to atmosphere.

Among the Fauves he was on especially friendly terms with the Chatou group, whose impulsive outbursts and expressionist tendencies have been alluded to. The *Dancer at the "Rat Mort"*, sloe-eyed and provocative with her black stockings and her décolleté, was portrayed simultaneously by Vlaminck and Derain—and was just the type of model who would have caught the fancy of Van Dongen and the Brücke painters. With his lusty northern temperament (his name means "Fleming") Vlaminck worked, as he frankly admitted, "by instinct, unmethodically," expressing "not an artistic but a human truth," which is an excellent definition of Expressionism. The most self-revealing of all his pictures is the series of portraits and nudes dating to 1904-1906, drastically simplified, riotously colored works in which "the model herself was nothing, all that mattered was the black of the eyes, the red of the lips."

More thoughtful and complex, Derain oscillated between a yearning for classicism and the vehemence of Expressionism. "Apart from emotion," he said to Vlaminck in 1903, "there is also the will to render it more or less expressive, to magnify it or minimize it." Copying Ghirlandaio's *Bearing of the Cross* at the Louvre in 1901, even then Derain felt it necessary "not only to add more color to it, but to intensify the expression." Even his large pointillist composition, *The Golden Age*, composed in vivid colors but by no means serene in spite of the title, displays some alarming distortions in the drawing of the figures.

"What I am after above all else," writes Matisse in his *Notes d'un Peintre*, "is expression." But he qualifies this a few lines further on: "Expression, as I see it,

Henri Matisse (1869-1954): Algerian Woman, 1909.

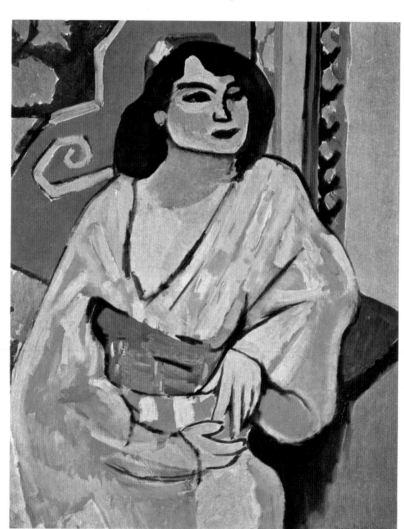

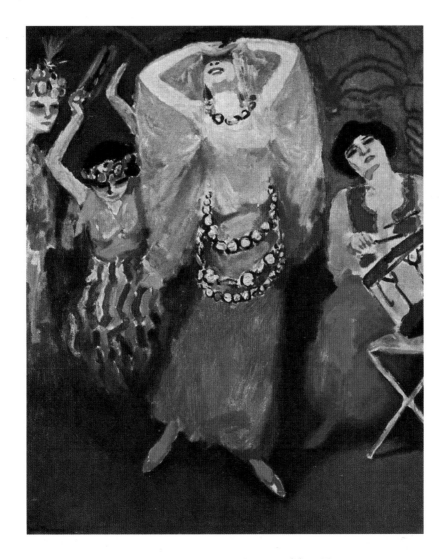

Kees van Dongen (1877-1968): Fatima and her Troupe, 1906.

does not lie in the passion that lights up a face or bursts out in a violent gesture. It lies in the whole arrangement of my picture." With Matisse tangible expression and pictorial means are one and indivisible, the picture content resolves itself entirely into its own spatial structure. With the German Expressionists, however, there always remained an emotional residue which was bound up with transcendental religious and mythical forces, and which, far from being absorbed by form, prevailed over form. Here is the fundamental difference (which Kirchner explicitly acknowledges) between the Latin and the Germanic attitude to painting—a difference based, moreover, on the two opposing principles of *decoration* and *illustration*. French painters of course have their soul struggles just as German painters do.

The plastic harmony and Arcadian serenity of so much of Matisse's work were only achieved, as we have seen, at the price of Titanic exertions in the molding of rebellious material. Indeed, a fierce expressivity erupts intermittently in his nudes of 1900, and again in the *Blue Nude* of 1907, in *The Gypsy* of 1906 and the exotic, vehement figure paintings of 1909, for example the *Woman in Green* and *Spanish Dancer with a Tambourine*, also the *Algerian Woman* which comes very close to Kirchner, with its "Kanaka face" (Louis Vauxcelles) heavily outlined in black.

It was during 1909 (according to Alfred Lichtwark, director of the Hamburg museum) that Matisse's influence was most keenly brought to bear not only on the Brücke group, but on young painters all over Germany. His growing influence was due partly to the famous art school which Matisse opened in Paris in 1908, largely organized by the Bavarian painter Hans Purrmann and attended by many young German artists; partly to his *Notes d'un Peintre* published in December 1908 and promptly translated into German and Russian; and partly to his exhibition at Cassirer's in Berlin in the winter of 1908-1909. Matisse himself made three trips to Germany between 1908 and 1910.

Spurred on by their own enthusiasm and stimulated by the example of Matisse and the Fauves, the Brücke painters enriched and matured their style, which came to full fruition at Dresden in the period between the autumn of 1907 and early 1911. Each year, during their summer holidays on the Baltic, the North Sea or the Lake of Moritzburg, north of Dresden, they painted from the nude figure in the open air and, working in terms of rhythmic surfaces of pure color circumscribed with dark contours, they sought to bring about that fusion of man and nature which is the nostalgic obsession of Nordic romanticism.

Robust and earthy, enamored of the seasons and the elements, Karl Schmidt-Rottluff was the first member of the group to leave the city, in 1906, and work from nature. He acted as the intermediary—the "bridge," as he put it himself—between Kirchner and Heckel, both highly strung city-dwellers, and Emil Nolde, a taciturn man of the soil. From 1907 to 1912 Schmidt-Rottluff spent each summer painting on the moors of Oldenburg, in the neighborhood of Dangast. The dunes and lonely desolation of the North German seaboard exactly suited his mystical turn of mind. After initiating his friends into the technique of lithography, he devoted himself to woodcuts after 1910, and this accentuated the rugged power and angular simplicity of his painting. During a summer holiday in Norway in 1911, he painted what is probably his masterpiece: *Lofthus*, a monumental landscape with something about it of the stained-glass window. The purity of the colors and their resolute decorative patterning fail to dispel the mood of mystery and tension with which this canvas is imbued. It stands out as one of the finest achievements of "German Fauvism."

Karl Schmidt-Rottluff (1884-1976): Lofthus, 1911.

A graphic artist to begin with, Erich Heckel did not fully develop his lyrical gifts and his strange crystalline light effects till after 1911, when the Brücke moved its headquarters to Berlin, where Pechstein, the least original but the most exuberant of them all, had been living since 1908. One of the last converts, in 1910,

Wassily Kandinsky (1866-1944): Arab Cemetery, 1909.

was Otto Mueller, whose art introduced a note of bucolic languor. After the move to Berlin their styles diverged, though all became increasingly expressionist.

Munich was also a busy art center, and there the first German Secession group was formed in 1892. Matisse made two trips to Munich, in 1908 and 1910. It was between these two dates that the Neue Künstlervereinigung (New Association of Munich Artists) was founded, and that Kandinsky and Jawlensky, influenced mainly by Matisse, went through their "Fauve" period. Both highly gifted colorists, the two Russian artists came to Munich independently in the same year, 1896, and met almost at once at Anton Azbe's art school. This was the beginning of a fruitful collaboration and a lifelong friendship. Kandinsky, aged thirty, had come from Moscow; Jawlensky, aged thirty-two, from St Petersburg with his companion Marianne von Werefkin. Both had given up promising careers, Kandinsky as a jurist and scientist, Jawlensky as an army officer, in order to devote themselves to painting. Both came under the momentary influence of Jugendstil, but Munich offered them a congenial atmosphere, Bohemian and cosmopolitan at once, in which the Slav element prevailed, with its vitality and mysticism, its inventive fancy and innate sense of color.

In 1901 Kandinsky founded an avant-garde group known as the Phalanx, and in 1902 he opened an art school of his own in Munich; one of his first pupils was Gabriele Münter, and she shared his life up to 1914. (The Münter donation to the Munich museum has thrown new light on the formative years of Kandinsky's art, hitherto little known, and on the change that came over his style in 1910.) In 1903-1904 she accompanied him on trips to Italy, Tunisia (Kairouan), France and Holland. In 1904 the Phalanx sponsored a neo-impressionist exhibition in Munich (visited by Kirchner), while the Kunstverein organized a large showing of works by Cézanne, Van Gogh and Gauguin. These two exhibitions revealed the new possibilities of color—and color was the problem that engrossed both Kandinsky and Jawlensky.

Jawlensky paid several visits to France and entered into contact with Matisse, Rouault and, through the monk Jan Verkade, with the Nabis and the Pont-Aven school. In 1905 he painted in Brittany and Provence, and for the first time

Wassily Kandinsky (1866-1944): Improvisation 6, 1909.

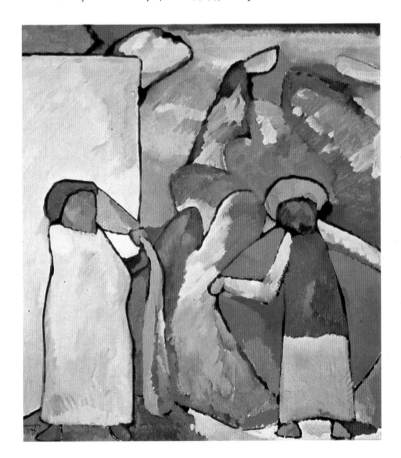

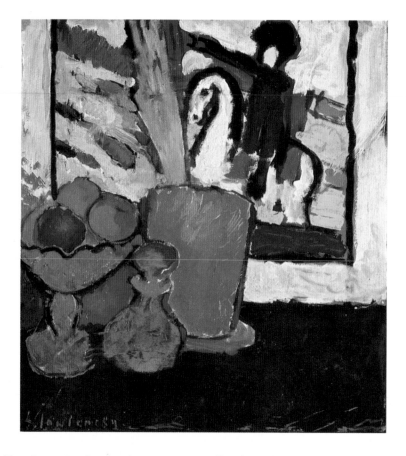

Alexei von Jawlensky (1864-1941): Still Life with a White Horse, 1912.

succeeded, to use his own words, "in rendering nature with tonalities as ardent as his own soul." Kandinsky and Jawlensky both exhibited in Paris at the historic Salon d'Automne of 1905, not in the Fauve room however, but in the Russian section organized by Diaghilev.

From the spring of 1906 to the spring of 1907, in the heyday of Fauvism, Kandinsky was living at Sèvres, just outside Paris. Though he was not personally acquainted with any of the French colorists, he saw their canvases, called at the Steins' and especially admired Matisse's work. Before returning to Munich, he stopped off at Dresden and exhibited with the Brücke. Kandinsky's early style up to 1907, sometimes neo-impressionist, more often neo-romantic, combined reminiscences of Russian folklore and legend with the decorative patterns of Jugendstil. Prompted by his stay in Paris, a great change came over his style in 1908-1909, while he was living at the foot of the Bavarian Alps in the charming village of Murnau. After a critical phase of anxiety and instability, he found his bearings again at Murnau and regained his self-confidence in the calm and serenity of a rustic

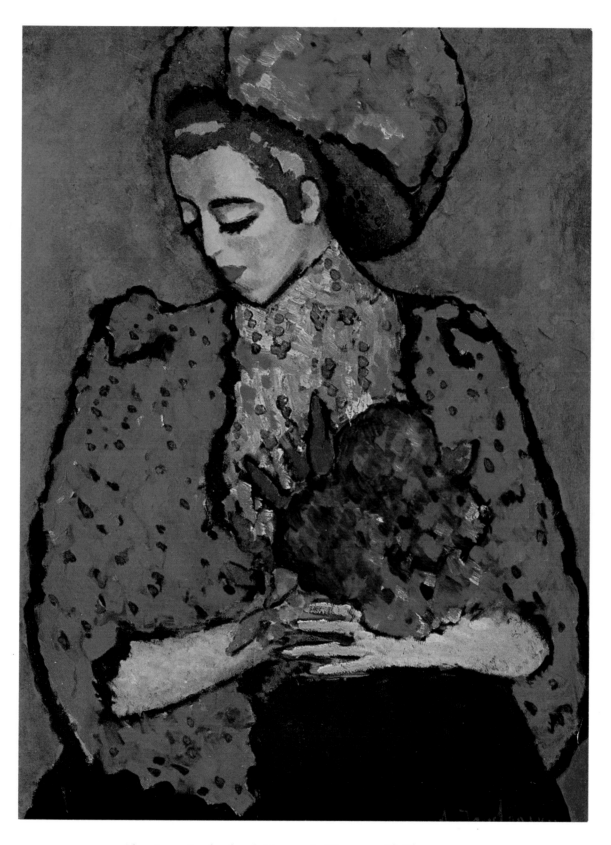

Alexei von Jawlensky (1864-1941): Woman with Flowers, 1909.

setting. He now met the aesthetician Wilhelm Worringer, author of *Abstraktion und Einfühlung* (1908), and began formulating his own ideas, which took shape in *Über das Geistige in der Kunst* (On the Spiritual in Art), written in 1910 and published in 1912, in which he justified the "inner necessity" of breaking away from natural appearances and materialism.

Munich's prestige as an art center was greatly increased in 1909 when Hugo von Tschudi was appointed director of the Bavarian Museums. In addition to frequent showings of contemporary painting, two large-scale exhibitions of Oriental art were now organized: one in 1909, devoted to Japanese and Chinese work, the other in 1910 (visited by Matisse), devoted to Islamic art. As a Slav, Kandinsky was as responsive to the refinements of Asiatic art as he was to all forms of popular art, and he delighted in the traditional painting on glass practised by the peasants of the Murnau region; something of its naïve expressiveness and bright, heavily outlined colors is to be found in his own style and technique.

Now appeared Kandinsky's first really creative works, conceived on more grandiose lines and painted on a larger scale than his earlier pictures: views of Murnau, of the village streets and the surrounding lakes and mountains, together with interiors and figure compositions, all built up in radiant harmonies of orange and blue, red and green. His Fauve period at Murnau was the decisive preparatory stage in the artist's increasingly accelerated advance toward abstraction.

In collaboration with Jawlensky, who came out to work with him at Murnau after his stimulating contacts with Matisse in Paris, Kandinsky founded in 1909 the New Association of Munich Artists, which held exhibitions in the winter of 1909-1910 and in the autumn of 1910. It was also in 1910 that Kandinsky crossed the threshold of non-figurative expression, thus carrying Impressionism and Fauvism to their logical conclusion. From now on, liberated from representational service, painting was free to pursue those melodies of color and rhythms of line which elicit "the response of the human soul." It is significant that Kandinsky now began calling his sketches "Improvisations" and his finished works "Compositions."

In 1911 he took part in founding the new group known as Der Blaue Reiter (The Blue Rider), which initiated an art of musical harmony and mystical fusion in contrast to the demonic tension and trenchant dissonances of Die Brücke. While never actually a member of the Blue Rider, Jawlensky was in close sympathy with the movement and gave consummate expression to the romantic religious fervor behind it. While painting many landscapes and simplified, luminescent still lifes marked by heavily drawn contours, he concentrated above all on the portrayal of the human face, hallowed and monumental, glowing with the unearthly radiance of an icon.

NOTES

Page 11:
Monet: *Street decked with Flags*, 1878.

Page 14:
Van Gogh: *The Fourteenth of July*, 1887.

Page 15:
Marquet: *The Fourteenth of July*, 1906.

Page 15:
Dufy: *The Fourteenth of July*, 1906.

The 14th of July of course is the French national holiday, and with houses and streets gaily decked with flags and bunting, it gave painters a golden opportunity of rendering bright colors in the broad sunlight of midsummer. Nearly all the Fauves interpreted this characteristic theme at least once, many of them several times, and it might almost be regarded as the emblem of the movement. First taken up in 1878 by Manet and Monet, the theme was handled next, with great brilliance and driving power, by Van Gogh during his stay in Paris in 1887. His version of it forms the link between the initial interpretation by Monet, with its phantasmagoric atmosphere of impressionist vibrancy, and the boldly simplified versions of the Fauves, notably those of Marquet and Dufy dating to 1906, which magnify the flat surface of the canvas and its chromatic intensity.

Page 87:
Kirchner: *The Artist and his Model*, 1907.

Page 92:
Matisse: *Algerian Woman*, 1909.

Page 93:
Van Dongen: *Fatima and her Troupe*, 1906.

With his vigorous, hypersensitive temperament and his intense visual curiosity, Kirchner was the dominant personality of the Brücke group. His work sometimes offers striking analogies with that of Matisse and Van Dongen. In view of his Dutch background, his themes and technique, and the advanced position he enjoyed at that time, it fell to Van Dongen to act as the link between French Fauvism and the Brücke group in Germany. On a trip to Paris in 1907 Max Pechstein sought him out and invited him to exhibit with the Brücke the following year in Dresden; Van Dongen accepted and sent in some watercolors and drawings.

Matisse made three successive trips to Germany between 1908 and 1910. By 1909, the year he painted his *Algerian Woman* and a series of exotic portraits, vehemently expressive works full of angular contours and flat, subacid colors, his influence had taken effect not only on the Brücke group but on the younger generation of artists all over Germany. Many analogies between the Brücke and Fauvism are due of course to common sources of inspiration: primitive art and post-impressionist painting. But with the Germans "psychic force" prevailed over "plastic form," while the emotive symbolism of Munch was as influential in Germany as the structural analysis of Cézanne was in France.

Page 89:
Kirchner: *Woman on a Blue Divan*, 1907.

In order to make it appear that they were contemporary with French Fauvism, Kirchner went to the trouble later in life of antedating some of the major works of his early period which were still in his possession, including this picture. Taut, compact forms and angular contours betray the influence of primitive arts and the woodcut. In fact one of the decisive elements in the formation of Kirchner's style and that of the whole Brücke group was their constant practice of making woodcuts, chiefly in color.

EVENTS YEAR BY YEAR

The dates of birth of the painters dealt with in this book fall between 1864 and 1884, as follows.

1864 March 13, Alexei von Jawlensky, Torzhok (Government of Tver), near Moscow.

1866 December 4, Wassily Kandinsky, Moscow.

1869 August 8, Louis Valtat, Dieppe.
December 31, Henri Matisse, Le Cateau (Nord).

1874 March 23, Henri-Charles Manguin, Paris.

1875 March 27, Albert Marquet, Bordeaux.

1876 April 4, Maurice Vlaminck, Paris.
November 8, Jean Puy, Roanne (Loire).

1877 January 26, Kees van Dongen, Delfshaven, near Rotterdam.
June 3, Raoul Dufy, Le Havre.

1879 February 6, Othon Friesz, Le Havre.
September 23, Charles Camoin, Marseilles.

1880 May 6, Ernst Ludwig Kirchner, Aschaffenburg (Bavaria).
June 10, André Derain, Chatou (Seine-et-Oise).

1882 May 13, Georges Braque, Argenteuil (Seine-et-Oise).

1884 December 1, Karl Schmidt-Rottluff, Rottluff (Saxony), near Chemnitz.

1892 Matisse and Marquet study at the Ecole des Arts Décoratifs, Paris.

1895 Matisse enters Gustave Moreau's studio at the Ecole des Beaux-Arts, Paris. Among his fellow students are Rouault, Desvallières, Piot and Evenepoel, soon to be joined by Camoin, Manguin and Marquet.

1895 Gauguin leaves on his second trip to Tahiti.
Cézanne exhibition at Vollard's.

1896 Matisse spends the summer painting in Brittany, at Belle-Ile. Kandinsky and Jawlensky come to Munich from Russia.

1896 Samuel Bing opens the Art Nouveau Gallery, Paris.
The magazine *Jugend* launched in Munich.
Death of Verlaine and Edmond de Goncourt.

1897 Van Dongen arrives in Paris from Holland.

1897 Controversy over the Caillebotte Bequest of impressionist paintings, which the French museum authorities refuse to accept in its entirety.

1898 Matisse goes to London in January to see Turner's paintings, at the suggestion of Pissarro, then spends a year in Corsica and the Toulouse region. After Gustave Moreau's death, Marquet and Camoin leave the Ecole des Beaux-Arts and sketch in the streets and music halls.
Friesz comes to Paris and enters Bonnat's class at the Ecole des Beaux-Arts.
Puy comes to Paris and enrolls at the Académie Julian.
Kirchner studies Dürer's woodcuts at Nuremberg.

1898 Death of Mallarmé, Gustave Moreau and Puvis de Chavannes.

1899 Matisse returns to Paris in February, takes a studio at 19 Quai Saint-Michel. Meets Derain and Puy at the Académie Carrière, where he does a series of nudes. Paints with Marquet in the Luxembourg Gardens and at Arcueil. Period of pre-Fauvism. Camoin is away on military service at Arles, then at Aix-en-Provence, where he meets Cézanne.

1899 Signac publishes *D'Eugène Delacroix au Néo-Impressionnisme*.
Group exhibition of the Nabis at Durand-Ruel's.

1900 Meeting of Vlaminck and Derain. They rent a studio together at Chatou.
Braque and Dufy come to Paris. Dufy joins Friesz at the Ecole des Beaux-Arts.
To earn some money Matisse and Marquet paint ceiling decorations at the Grand Palais, which is being built for the Paris World's Fair.

1900 Picasso's first trip to Paris.
Seurat retrospective in the offices of the *Revue Blanche*.
Paris World's Fair. Centennial exhibition of French art.

1901 Matisse and Marquet exhibit at the Salon des Indépendants, where they show their work annually up to 1908.
Derain introduces Vlaminck to Matisse at the Van Gogh exhibition at Bernheim-Jeune's.
Marquet works in Normandy with Manguin.
After summering in Brittany (Belle-Ile), Derain leaves in the autumn for three years' military service; corresponds with Vlaminck.
Friesz works in the Creuse region of central France, where he meets Guillaumin.
Kirchner and Bleyl study architecture at the Technical Institute in Dresden.

1901 Van Gogh retrospective at Bernheim-Jeune's.
Opening of the Berthe Weill Gallery.
Death of Toulouse-Lautrec.

1902 Matisse and Marquet exhibit at Berthe Weill's. Too poor to stay in Paris, Matisse lives with his parents at Bohain, in Picardy.
Discharged from the army, Camoin returns to Paris. Friesz works in the Creuse, Vlaminck at Chatou, Marquet in Paris (views of Notre-Dame).
Manguin exhibits at the Salon des Indépendants.
Kandinsky opens an art school in Munich and heads the Phalanx group.

1902 Lautrec retrospectives at Durand-Ruel's and the Indépendants.
Death of Emile Zola.

1903 Again Matisse stays with his parents at Bohain: dark period of financial difficulties. Encouraged by Pissarro, Friesz exhibits at the Salon des Indépendants, as do Camoin, Manguin and Dufy.
Kandinsky makes a trip to Tunisia.

> 1903 Founding of the Salon d'Automne.
> Exhibition of Islamic art in Paris.
> Death of Gauguin, Pissarro and Whistler.

1904 Matisse's first one-man show at Vollard's. Works in the summer at Saint-Tropez with Signac and Cross.
Discharged from the army, Derain rejoins Vlaminck at Chatou.
At the sight of Matisse's canvases at the Salon d'Automne, Friesz abandons his early impressionist style and takes to Fauvism.
Kirchner discovers Negro art and Polynesian carvings at the Ethnological Museum in Dresden.

> 1904 Neo-Impressionist and Post-Impressionist exhibition in Munich.
> Exhibition of French Primitives in Paris.

1905 The Fauves create a sensation at the Salon d'Automne, Paris.
Founding of the Brücke group in Dresden (Kirchner, Schmidt-Rottluff, Heckel, Bleyl).
Matisse exhibits *Luxe, calme et volupté* at the Salon des Indépendants; Dufy is converted at the sight of it.
Matisse and Derain at Collioure. Marquet, Camoin and Manguin at Saint-Tropez. Friesz at Antwerp and La Ciotat. Jawlensky in Brittany and Provence. Vlaminck and Derain in contact with Van Dongen and the Bateau-Lavoir group in Montmartre; revelation of Negro sculpture. Matisse and Friesz set up their studios in the disused Couvent des Oiseaux, Rue de Sèvres. Derain and Puy sign contracts with Vollard, Marquet with Druet. Matisse meets Gertrude and Leo Stein, who become his best patrons.

> 1905 Seurat and Van Gogh retrospective at the Salon des Indépendants. Manet retrospective at the Salon d'Automne.
> Van Gogh exhibition at the Arnold Gallery, Dresden.

1906 Matisse exhibits *The Joy of Life* at the Salon des Indépendants. Second one-man show at Druet's in March. First trip to North Africa (Biskra). Summer at Collioure. Meeting of Matisse and Picasso at the Steins' Paris apartment.
Derain in London (views of the Thames) and Provence. Marquet and Dufy in Normandy (*The Fourteenth of July*).
After exhibiting at the Indépendants, Braque goes to Antwerp with Friesz, adopts Fauvism, spends the autumn at L'Estaque. Vlaminck at Chatou; signs a contract with Vollard. Manguin at Saint-Tropez.
Kandinsky makes a stay at Sèvres, near Paris.
Brücke exhibition at Dresden. Nolde joins the group (only to withdraw in 1907), followed by Max Pechstein, Cuno Amiet and Axel Gallen.

> 1906 Large-scale Gauguin retrospective at the Salon d'Automne.
> Gris and Modigliani arrive in Paris.
> Death of Cézanne.

1907 Matisse travels in Italy, then opens an art school in Paris. Article by Apollinaire on Matisse. Marquet, Camoin and Friesz in London. Braque at La Ciotat and L'Estaque, Derain at Cassis and Avignon, Dufy at Le Havre and Marseilles. Camoin in Spain, Puy at Talloires on the Lake of Annecy.
Pechstein in Italy, then in Paris, where he meets Van Dongen.
Brücke exhibition at the Richter Gallery, Dresden. The group paint open-air nudes during the summer on the Lake of Moritzburg.

 1907 Opening of the Kahnweiler Gallery in Paris.
 Picasso paints *Les Demoiselles d'Avignon*.
 Cézanne retrospectives at the Salon d'Automne and the Bernheim-Jeune Gallery.
 Artists' and writers' banquet in Picasso's studio in honor of the Douanier Rousseau.

1908 Matisse makes a trip to Munich, publishes "Notes of a Painter" in *La Grande Revue* (December), exhibits in Berlin and New York.
Marquet and Manguin in Naples, Derain and Vlaminck at Martigues, Dufy in Normandy and Provence.
Braque holds a one-man show at the Kahnweiler Gallery, presented by Apollinaire.
Van Dongen invited to exhibit with the Brücke in Dresden. Kandinsky and Jawlensky at Murnau in the Bavarian Alps near Munich.

 1908 Wilhelm Worringer publishes *Abstraktion und Einfühlung* ("Abstraction and Empathy"), Munich, a book in which "for the first time a will to abstraction in art was postulated as a recurrent historical phenomenon" (Sir Herbert Read).

1909 Founding in Munich of the Neue Künstlervereinigung München (New Association of Munich Artists), with Kandinsky, Jawlensky, Marianne von Werefkin and Gabriele Münter, later joined by Alfred Kubin. They hold their first exhibition in December at the Moderne Galerie.

 1909 Hugo von Tschudi appointed director of the Bavarian museums.
 Exhibition of Japanese and Chinese art in Munich.
 First appearance in Paris of Diaghilev's Russian Ballet.

1910 Second exhibition in September of the New Association of Munich Artists, again at Heinrich Thannhauser's Moderne Galerie, this time with the participation of Braque, Derain, Vlaminck, Rouault, Picasso and Van Dongen.
Large Matisse retrospective exhibition in February at the Bernheim-Jeune Gallery, Paris. In October Matisse and Marquet go to Munich together to visit the big exhibition of Islamic art.
In Munich Kandinsky writes his essay *Über das Geistige in der Kunst* ("Concerning the Spiritual in Art"), in which "for the first time an abstract 'art of internal necessity' was proclaimed and justified as a contemporary phenomenon" (Sir Herbert Read).

1911 The Brücke group moves from Dresden to Berlin.
Third exhibition and break-up of the New Association of Munich Artists.
Founding in Munich of Der Blaue Reiter group (The Blue Rider), with Kandinsky, Franz Marc and August Macke, later joined by Paul Klee. First Blue Rider exhibition in December at Thannhauser's Moderne Galerie, Munich.

BIBLIOGRAPHY

Source Works

H. MATISSE, "Notes d'un peintre," *La Grande Revue*, Paris, December 25, 1908; in English in J.D. FLAM, *Matisse on Art*, London and New York 1973. – M. VLAMINCK, *Le Tournant dangereux*, Paris 1929; *Portraits avant décès*, Paris 1943; *Dangerous Corner*, London 1961. – G. DUTHUIT, "Le Fauvisme," *Cahiers d'Art*, Paris 1929-1931. – M. PUY, *L'Effort des peintres modernes*, Paris 1933. – A. DERAIN, *Lettres à Vlaminck*, Paris 1955. – A. BILLY, *L'époque contemporaine*, Paris 1956. – M. DENIS, *Journal*, vol. I 1884-1904, vol. II 1905-1920, Paris 1957. – A. VOLLARD, *Souvenirs d'un marchand de tableaux*, Paris 1937, 1957; *Recollections of a Picture Dealer*, Boston 1936.

General Works

C. MALPEI, *Notes sur l'art d'aujourd'hui et peut-être de demain*, Paris 1911. – A. SALMON, *La jeune peinture française*, Paris 1912. – M. DENIS, *Théories 1890-1910*, Paris 1912. – C. BELL, *Since Cézanne*, New York 1923. – W. PACH, *The Masters of Modern Art*, New York 1924. – C. EINSTEIN, *Die Kunst des 20. Jahrhunderts*, Berlin 1926. – *Histoire de l'art contemporain* (edited by R. Huyghe), Paris 1935. – R. ESCHOLIER, *La peinture française, XXᵉ siècle*, Paris 1937. – R. GOLDWATER, *Primitivism in Modern Painting*, New York and London 1938. – C. ZERVOS, *Histoire de l'art contemporain*, Paris 1938. – R. HUYGHE, *Les Contemporains*, Paris 1939; new edition, 1949. – R.H. WILENSKI, *Modern French Painters*, London and New York 1940; 3rd edition, 1954. – B. DORIVAL, *Les étapes de la peinture française*, vol. II, Paris 1944. – C.E. GAUSS, *The Aesthetic Theories of French Artists*, Baltimore 1949. – *History of Modern Painting*, vol. II: *Matisse-Munch-Rouault*, sections on Fauvism by M. RAYNAL, on Die Brücke and German Expressionism by A. RÜDLINGER, Geneva and New York 1950. – F. FELS, *L'art vivant de 1900 à nos jours*, Geneva 1950. – P. FRANCASTEL, *Peinture et Société*, Lyons 1951. – P.F. SCHMIDT, *Geschichte der Modernen Malerei*, Stuttgart 1952. – M. RAYNAL, *Modern Painting*, Geneva 1953. – *Dictionnaire de la Peinture moderne*, Paris 1954. – A.H. BARR, *Masters of Modern Art*, New York 1954. – W. HAFTMANN, *Malerei im 20. Jahrhundert*, Munich 1954-1955. – A. SALMON, *Souvenirs sans fin*, 2 vols., Paris 1955-1956. – B. DORIVAL, *Les peintres du XXᵉ siècle*, Paris 1957. – U. APOLLONIO, *Fauves et cubistes*, Paris 1959. – F. FELS, *Le roman de l'art vivant de Claude Monet à Bernard Buffet*, Paris 1959. – H. READ, *A Concise History of Modern Painting*, London and New York 1959. – J. CASSOU, E. LANGUI, N. PEVSNER, *Les sources du XXᵉ siècle*, Paris 1961. – R. SHATTUCK, *The Origins of the Avant-Garde in France, 1885 to World War I*, New York 1961. – D. VALLIER, *Histoire de la peinture 1870-1940. Les mouvements d'avant-garde*, Brussels 1963. – R.L. DELEVOY, *Dimensions of the 20th Century*, Geneva-London-New York 1965. – P. FRANCASTEL, *Peinture et société*, Paris 1965. – J.P. CRESPELLE, *Les maîtres de la belle époque*, Paris 1966. – M.C. JALARD, *Le post-impressionnisme*, Lausanne 1966. – M. GIRY, *La peinture à Paris en 1905*, Strasbourg 1967. – G.H. HAMILTON, *Painting and Sculpture in Europe, 1880 to 1940*, Harmondsworth and Baltimore 1967. – R. MOULIN, *Le marché de la peinture en France*, Paris 1967. – G. and P. FRANCASTEL, *Le portrait*, Paris 1969. – G.C. ARGAN, *L'arte moderna 1770-1970*, Florence 1970. – R. HUYGHE and J. RUDEL, *L'art et le monde moderne*, Paris 1970. – D. MAYBON and G. SCHURR, *Carnet des arts*, Paris 1970. – J. WILLETT, *Expressionism*, London and New York, 1970. – A. BOWNESS, *Modern European Art*, London 1972. – J.E. MULLER and F. ELGAR, *A Century of Modern Painting*, London 1972.

Studies of Fauvism

G. DIEHL, *Les Fauves*, Paris 1943. – G. DUTHUIT, *Les Fauves*, Geneva 1949; *The Fauvist Painters*, New York 1950. – G. MARUSSI, *I "Fauves"*, Venice 1950. – J.E. MULLER, *Le Fauvisme*, Paris 1956; *Fauvism*, London 1957. – L. VAUXCELLES, *Le fauvisme*, Geneva 1958. – G. JEDLICKA, *Der Fauvismus*, Zurich 1961. – J.P. CRESPELLE, *Les Fauves*, Neuchâtel 1962; *The Fauves*, London and New York 1962. – C. CHASSÉ,

Les Fauves et leur temps, Lausanne and Paris 1963. – R. NEGRI, *Matisse e i Fauves*, Milan 1969. – G. DIEHL, *Les Fauves*, Paris 1971; *The Fauves*, New York 1971. – W.J. COWART, *"Ecoliers" to "Fauves," Matisse, Marquet and Manguin Drawings 1890-1906*, Baltimore 1972. – J. ELDERFIELD, *The "Wild Beasts". Fauvism and its Affinities*, New York 1976. – E.C. OPPLER, *Fauvism Reexamined*, New York and London 1976. – M. GIRY, *Le fauvisme*, Neuchâtel 1981.

Magazine Articles

L. VAUXCELLES in *Gil Blas*, October 17, 1905 and March 20, 1906. – M. DENIS, "La réaction nationaliste," *L'Ermitage*, November 15, 1905. – A. GIDE, "Promenade au Salon d'Automne," *Gazette des Beaux-Arts*, December 1905. – M. PUY in *La Phalange*, September 15, 1907. – G. BURGESS, "The Wild Men of Paris," *Architectural Record*, New York, May 14, 1910. – W. GEORGE, "Le mouvement fauve," *L'Art Vivant*, March 15, 1927. – J. DE LASSUS, "Les Fauves," *L'Amour de l'Art*, June 1927. – A. SALMON, "Les Fauves et le fauvisme," *L'Art Vivant*, May 1, 1927. – P. FIERENS, "Le Fauvisme," *Cahiers de Belgique*, April-May 1931. – L. VAUXCELLES, "Les Fauves," *Gazette des Beaux-Arts*, December 1934. – E. TÉRIADE, "Constance du fauvisme," *Minotaure*, October 15, 1936. – P. FIERENS, "Matisse e il fauvismo," *Emporium*, October 1938. – D. SUTTON, "The Fauves," *World Review*, May 1947. – D. SUTTON, "The Fauves," *Burlington Magazine*, September 1950. – B. DORIVAL, "Fauves: The 'Wild Beasts' Tamed," *Art News Annual*, New York 1952-1953. – A. CHASTEL, "Le fauvisme, ou l'été chaud de la peinture," *Le Monde*, August 21, 1959. – B. DORIVAL, "L'art de la Brücke et le fauvisme," *Art de France*, I, 1961. – C. CHASSÉ, "L'histoire du fauvisme revue et corrigée," *Connaissance des Arts*, October 1962. – M. HOOG, "La Direction des Beaux-Arts et les Fauves, 1903-1905," *Art de France*, III, 1963. – H. DORRA, "The 'Wild Beasts', Fauvism and its Affinities at the Museum of Modern Art," *Art Journal*, XXXVI/1, Autumn 1976.

On Fauvism-Expressionism

H. BAHR, *Expressionismus*, Munich 1918. – K. EDSCHMID, *Über den Expressionismus in der Literatur und die neue Malerei*, Berlin 1921. – U. APOLLONIO, *Die Brücke e la cultura dell'espressionismo*, Venice 1952. – L.G. BUCHHEIM, *Die Künstlergemeinschaft Brücke*, Feldafing 1956. – W. HAFTMANN, A. HENTZEN, W.S. LIEBERMAN, *German Art of the Twentieth Century*, New York 1957. – B.S. MYERS, *Expressionism*, London and New York 1957. – P. SELZ, *German Expressionist Painting*, Berkeley and Los Angeles 1957. – L.G. BUCHHEIM, *Der Blaue Reiter und die Neue Künstlervereinigung München* and *Graphik des deutschen Expressionismus*, Feldafing 1959. – R. BRINKMANN, *Expressionismus-Forschungsprobleme*, Stuttgart 1961. – D. SCHMIDT (editor), *Manifeste Manifeste 1905-1933. Schriften deutscher Künstler des 20. Jahrhunderts*, I, Dresden 1965. – J. WILLETT, *Expressionism*, London and New York 1970. – E. ROTERS, *Europäische Expressionisten*, Gütersloh 1971. – K. SOTRIFFER, *Expressionismus und Fauvismus*, Vienna 1971. – W.D. DUBE, *Expressionism*, London 1972 and New York 1973. – H.J. SCHMIDT, *Die Expressionismusdebatte. Materialien zu einer marxistischen Realismuskonzeption*, Frankfurt 1973. – E. EYKMAN, *Denk- und Stilformen des Expressionismus*, Munich 1974. – B. DENVIR, *Fauvism and Expressionism*, London 1975. – R. HAMANN and J. HERMANDT, *Expressionismus*, Berlin 1975. – S. VIETTA and H.G. KEMPER, *Expressionismus*, Berlin 1975. – G. BOUDAILLE, *Les peintres expressionnistes*, Paris 1976. – L. RICHARD, *D'une Apocalypse à l'autre*, Paris 1976. – S. VON WIESE, *Graphik des Expressionismus*, Stuttgart 1976. – J.M. PALMIER, *L'expressionnisme comme révolte*, Paris 1978. – R. BRINKMANN, *Expressionismus. Internationale Forschung zu einem internationalen Phänomen*, Stuttgart 1980. – J.M. PALMIER, *L'expressionnisme et les arts*, Paris 1980. – W.D. DUBE, *Expressionists and Expressionism*, Geneva-London-New York 1983.

Individual Artists

BRAQUE:
 C. EINSTEIN, *Braque*, Paris 1934. – J. PAULHAN, *Braque le patron*, Geneva and Paris 1946. – *Cahiers de Georges Braque, 1917-1947*, Paris 1948. – H.R. HOPE, *Georges Braque*, New York 1949. – *Le jour et la nuit. Cahiers de Georges Braque, 1917-1952*, Paris 1952. – J. PAULHAN, "Vie imagée de G. Braque," *Arts*, 1952. – S. FUMET, G. LIMBOUR, G. RIBEMONT-DESSAIGNES, "Braque," *Le Point*, 1953. – D. VALLIER, "Braque, la peinture et nous," *Cahiers d'Art*, 1954. – D. COOPER, *Braque*, exhibition catalogue, Edinburgh and London 1956. – M. GIEURE, *Braque*, Paris 1956. – J. RICHARDSON, *Braque*, London 1959. – J. RUSSELL, *Georges Braque*, London 1959. – A. RÜDLINGER, P. VOLBOUDT, C. EINSTEIN, *Braque*, exhibition catalogue, Kunsthalle, Basel 1960. – J. LEYMARIE, *Braque*, Geneva-London-New York 1961. – D. COOPER, *Braque*, exhibition catalogue, Haus der Kunst, Munich 1963. – *Donation Braque*, exhibition catalogue, Musée du Louvre, Paris 1965. – S. FUMET, *Braque*, Paris 1965. – E. MULLINS, *Braque*, London 1968. – R. COGNIAT, *Braque*, Paris

1970. – N. POUILLON, *Braque*, Paris 1970. – C. BRU-
NET, *Braque et l'espace*, Paris 1971. – P. DESCARGUES
and M. CARRA, *Tout l'œuvre peint de Braque, 1908-
1929*, Paris 1973. – M. RICHET and N. POUILLON,
"G. Braque à l'Orangerie des Tuileries," *La Revue
du Louvre et des Musées de France*, 1973. – J. LEYMA-
RIE, M. RICHET, N. POUILLON, *Braque*, exhibition
catalogue, Orangerie des Tuileries, Paris 1973-1974.
– M. PLEYNET, "Georges Braque et les écrans tru-
qués," *Art Press*, 1973-1974. – N. POUILLON, *Catalo-
gue raisonné de l'œuvre de Braque*, Paris 1982.

DERAIN:

D.H. KAHNWEILER, *André Derain*, Leipzig 1920.
– E. FAURE, *Derain*, Paris 1923. – A. SALMON, *De-
rain*, Paris 1929. – J. LEYMARIE, *Derain*, Geneva 1948.
– D. SUTTON, *André Derain*, exhibition catalogue,
Wildenstein Gallery, London 1957. – A. GIACO-
METTI, *Dessins de Derain*, exhibition catalogue, Gale-
rie Maeght, Paris 1957. – A. SALMON and F. FELS,
Derain, exhibition catalogue, Asnières 1958. – *De-
rain*, Galerie Maeght, Paris 1958. – *Derain*, Musée de
l'Athénée, Geneva 1959. – D. SUTTON, *André De-
rain*, London 1959. – G. PAPAZOFF, *Derain mon co-
pain*, Paris 1960. – *Derain*, Museum of Fine Arts,
Houston 1961. – *Derain*, Galerie Bellechasse, Paris
1962. – P. ELGAR, catalogue preface, Musée Cantini,
Marseilles 1964. – J. BOURET, catalogue preface,
Hirschyard Adler Galleries, New York 1964. –
J. LEYMARIE and P. DIAMAND, *Derain*, exhibition
catalogue, Royal Scottish Academy, Edinburgh
and Royal Academy, London 1967. – B. DORIVAL,
"Un chef-d'œuvre fauve de Derain au Musée Na-
tional d'Art Moderne," *La Revue du Louvre et des
Musées de France*, 1967. – B. DORIVAL, "Un album
de Derain au Musée National d'Art Moderne," *La
Revue du Louvre et des Musées de France*, 1969. –
Derain, Galerie Knoedler, Paris 1971. – M. HOOG,
" 'Les Deux Péniches' de Derain, Musée National
d'Art Moderne," *La Revue du Louvre et des Musées
de France*, 1972. – A. BOWNESS and A. CALLEN, *The
Impressionists in London*, exhibition catalogue, Hay-
ward Gallery, London 1973. – *Derain connu et mé-
connu*, exhibition catalogue, Musée Toulouse-
Lautrec, Albi 1974. – *Derain*, Galerie Paul Vallot-
ton, Lausanne 1975. – M. GIRY, "Le curieux achat
fait à Derain et à Vlaminck au Salon des Indépen-
dants de 1905 ou deux tableaux retrouvés," *L'Œil*,
1976. – M. GIRY, "Une composition de Derain: 'La
Danse'," *Archives de l'art français*, 1976. – J. BOURET,
catalogue preface, Galerie Schmit, Paris 1976. –
J. LEYMARIE and I. MONOD-FONTAINE, exhibition
catalogue, Villa Medici, Rome and Grand Palais,
Paris 1976-1977. – M. KELLERMAN, *Catalogue rai-
sonné de l'œuvre de Derain* (in preparation).

DUFY:

M. BERR DE TURIQUE, *Raoul Dufy*, Paris 1930. –
P. CAMO, *Dufy l'enchanteur*, Lausanne 1947. – P.
COURTHION, *Raoul Dufy*, Geneva 1951. – J. LASSAI-
GNE, *Dufy*, Geneva and New York 1954. – *Dufy*,
Musée de Honfleur and Musée Cantini, Marseilles,
1954. – *Dufy*, San Francisco Museum of Art, 1954.
– *Dufy*, Musée des Beaux-Arts, Lyons 1957. –
F. DAULTE, "Marquet et Dufy devant les mêmes
motifs," *Connaissance des Arts*, 1957. – B. DORIVAL,
"Les Affiches à Trouville," *La Revue des Arts*, 1957.
– M. BRION, *Dufy*, London 1959. – *Dufy*, Musée-
Maison de la Culture, Le Havre 1963. – B. DORIVAL,
Dufy, exhibition catalogue, Musée du Louvre, Paris
1963. – B. DORIVAL, "Le legs de M^me Raoul Dufy
au Musée National d'Art Moderne," *La Revue du
Louvre et des Musées de France*, 1963. – P. QUONIAM
and G. VIATTE, *Dufy*, exhibition catalogue, Lille,
Colmar and Chambéry, 1964. – J. THIRION, "Le legs
Matisse et Dufy," *Art de France*, 1964. – R. CO-
GNIAT, *Raoul Dufy*, Paris 1967. – B. DORIVAL, cata-
logue preface, National Museum of Western Art,
Tokyo and National Museum of Modern Art,
Kyoto 1968. – *Dufy*, exhibition catalogue, Kunst-
verein, Hamburg and Folkwang Museum, Essen
1967-1968. – D. DEMETZ, "Le legs de M^me Raoul
Dufy au plus grand nombre de musées français," *La
Revue du Louvre et des Musées de France*, 1968. –
Dufy, exhibition catalogue, Musée des Beaux-Arts,
Bordeaux 1970. – A. WERNER, *Raoul Dufy*, New
York 1970. – G. MARTIN-MÉRY, "Hommage à
Raoul Dufy," *La Revue du Louvre et des Musées de
France*, 1970. – M. LAFFAILLE, *Raoul Dufy, catalogue
raisonné de l'œuvre peint*, Geneva 1972. – *Raoul Dufy*,
exhibition catalogue, Haus der Kunst, Munich 1973.
– *Hommage à Raoul Dufy*, exhibition catalogue,
Grand Palais, Paris 1973. – *Dufy*, exhibition catalo-
gue, Sporting Club d'Hiver, Monte Carlo 1974. –
Dufy, exhibition catalogue, Wildenstein Gallery,
London 1975. – *Œuvres de R. Dufy*, exhibition cata-
logue, Musée d'Art Moderne de la Ville de Paris,
1976. – P. LÉVY, *Des artistes et un collectionneur*, Paris
1976.

FRIESZ:

A. SALMON, *E.O. Friesz et son œuvre*, Paris 1920.
– F. FLEURET, C. VILDRAC, A. SALMON, *Othon
Friesz, œuvres 1901-1927*, Paris 1928. – R. BRIELLE,
Othon Friesz, Paris 1930. – P. DU COLOMBIER,
"Othon Friesz," *La Revue Française*, November
1952. – M. GAUTIER, *Othon Friesz*, Geneva 1957. –
Friesz, exhibition catalogue, Musée Galliéra, Paris
1959. – M. GIRY, "Le paysage à figures chez Othon
Friesz, 1907-1912," *Gazette des Beaux-Arts*, January
1967. – M. GIRY, "A propos d'un tableau d'Othon

Friesz au Musée National d'Art Moderne," *La Revue du Louvre et des Musées de France*, 1970. – *Friesz*, exhibition catalogue, Grenier à Sel, Honfleur 1971. – *Friesz*, Galerie Drouant, Paris 1973.

JAWLENSKY:

W. GROHMANN, "L'évolution de la figure chez Jawlensky," *Cahiers d'Art*, 1934. – C. WEILER, *Alexej von Jawlensky, der Maler und Mensch*, Wiesbaden 1955. – C. WEILER, *Jawlensky*, exhibition catalogue, Galerie Fricker, Paris 1956. – F. MEYER, *Jawlensky*, exhibition catalogue, Kunsthalle, Berne 1957. – C. WEILER, *Alexej von Jawlensky*, Cologne 1959 (with bibliography and catalogue). – *Alexej Jawlensky*, exhibition catalogue, Lyons 1970. – *Alexej Jawlensky*, exhibition catalogue, Munich and Baden-Baden 1983.

KANDINSKY:

W. KANDINSKY, *Über das Geistige in der Kunst*, Munich 1911, Bern 1952; *Concerning the Spiritual in Art and Painting in Particular*, New York 1947. – W. KANDINSKY, *Klänge, Gedichte in Prosa*, Munich 1913. – W. KANDINSKY, *Rückblicke*, Munich 1913. – H. ZEHDER, *Wassily Kandinsky*, Dresden 1920. – W. GROHMANN, *Wassily Kandinsky*, Leipzig 1924. – M. BILL and others, *Wassily Kandinsky*, Paris and Boston 1951. – W. KANDINSKY, *Essays über Kunst and Künstler*, Stuttgart 1955, Bern 1963. – J. EICHNER, *Kandinsky und Gabriele Münter*, Munich 1957. – W. GROHMANN, *Kandinsky*, Cologne and New York 1958, London 1959. – H. READ, *Kandinsky*, London 1959. – M. BRION, *Kandinsky*, Paris 1960, London 1961. – J. CASSOU, *Interférences, aquarelles et gouaches*, Paris 1960. – *Kandinsky Retrospective*, Solomon R. Guggenheim Museum, New York 1962. – P. VOLBOUDT, *Kandinsky 1896-1921* and *1922-1944*, 2 vols., Paris 1963. – J. LASSAIGNE, *Kandinsky*, Geneva and New York 1964. – F. WHITFORT, *Kandinsky*, London 1967. – H.K. ROETHEL, *Kandinsky, Das graphische Werk*, Cologne 1970. – H.K. ROETHEL and J.K. BENJAMIN, *Kandinsky. Werkverzeichnis der Ölgemälde. Catalogue of the Oil Paintings*, Vol. I, 1900-1915, Munich and London 1982.

KIRCHNER:

E.L. KIRCHNER, *Chronik KG Brücke 1913*, Berlin 1916. – W. GROHMANN, *Das Werk E.L. Kirchners*, Munich 1926. – E. RATHKE, *Kirchner*, exhibition catalogue, Württembergischer Kunstverein, Stuttgart 1956. – W. GROHMANN, *E.L. Kirchner*, Stuttgart 1958, London and New York 1961. – A. DUBE-HEYNIG, *E.L. Kirchner. Graphik*, Munich 1961. – A. and W.D. DUBE, *E.L. Kirchner. Das graphische Werk*, 2 vols., Munich 1967 (catalogue). – D.E. GORDON, *Ernst Ludwig Kirchner*, Munich 1968 (catalogue of

paintings). – E.W. KORNFELD, *E.L. Kirchner. Nachzeichnung seines Lebens*, Bern 1979. – *Ernst Ludwig Kirchner*, exhibition catalogue, Berlin, Munich, Cologne, Zurich 1980.

MANGUIN:

C. TERRASSE, *Eloge d'Henri Manguin*, Paris 1954. – *Manguin*, exhibition catalogue, Musée Toulouse-Lautrec, Albi 1957. – *Manguin*, exhibition catalogue, Galerie Motte, Geneva 1958. – *Manguin: tableaux fauves*, Galerie de Paris, Paris 1962. – P. CABANNE, *Henri Manguin*, Neuchâtel 1964. – *Manguin*, exhibition catalogue, Musée des Beaux-Arts, Neuchâtel 1964. – C. TERRASSE and others, "Manguin il Fauve," *Arti*, Milan, May 1969. – *Manguin*, exhibition catalogue, Städtische Kunsthalle, Düsseldorf 1969. – *Manguin in America*, exhibition catalogue, University of Arizona Museum of Art, Tucson 1974-1975. – *Manguin*, exhibition catalogue, Galerie Paul Vallotton, Lausanne 1980. – M.C. SAINSAULIEU, *Henri Manguin: catalogue raisonné de l'œuvre peint*, Neuchâtel 1980. – P. GASSIER, *Manguin*, exhibition catalogue, Fondation Pierre Gianadda, Martigny (Switzerland) 1983.

MARQUET:

C.L. PHILIPPE, in *La Grande Revue*, 1908. – G. BESSON, *Marquet*, Paris 1920, 1929, 1948. – C. ROGER-MARX, "Marquet," *Gazette des Beaux-Arts*, March 1939. – *Albert Marquet, 1875-1947*, exhibition catalogue, Musée d'Art Moderne, Paris 1948. – M. MARQUET, *Marquet*, Paris 1951 and 1955. – M. MARQUET and F. DAULTE, *Marquet*, Paris 1953. – *Marquet*, exhibition catalogue, Musée Toulouse-Lautrec, Albi 1957. – B. DORIVAL, "Nouvelles œuvres de Matisse et Marquet au Musée National d'Art Moderne," *La Revue des Arts*, 1957. – F. DAULTE, "Marquet et Dufy devant les mêmes motifs," *Connaissance des Arts*, 1957. – *Albert Marquet*, exhibition catalogue, San Francisco Museum of Art, 1958. – F. JOURDAIN, *Marquet*, Paris 1959. – *Marquet*, exhibition catalogue, Musée des Beaux-Arts, Lyons 1962. – *Albert Marquet*, exhibition catalogue, Kunstverein, Hamburg 1964-1965. – *Albert Marquet*, exhibition catalogue, Musée des Beaux-Arts, Bordeaux 1975 and Orangerie des Tuileries, Paris 1975-1976. – J.C. MARQUET, *Catalogue raisonné de l'œuvre de Marquet* (in preparation).

MATISSE:

M. SEMBAT, *Matisse et son œuvre*, Paris 1920. – C. ZERVOS, "Notes sur la formation et le développement de Matisse," and R. FRY, "Henri Matisse," *Cahiers d'Art* 5-6, 1931. – R. ESCHOLIER, *Henri Matisse*, Paris 1937. – A.H. BARR, Jr., *Matisse: His Art*

and His Public, New York 1951 (with bibliography). – F.L. TRAPP, The Paintings of Henri Matisse: Origins and Early Development (1890-1917), Ph.D. thesis, Harvard 1951. – G. DUTHUIT, Matisse, période fauve, Paris 1956. – R. ESCHOLIER, Matisse, ce vivant, Paris 1956. – B. DORIVAL, "Nouvelles œuvres de Matisse et Marquet au Musée National d'Art Moderne," La Revue des Arts, 1957. – J. LASSAIGNE, Matisse, Geneva and New York 1959. – J. LEYMARIE, H. READ, W.S. LIEBERMAN, Matisse Retrospective, University of California Art Galleries, Los Angeles 1966. – L. ARAGON and N.S. MANGIN, A la rencontre de Matisse, Fondation Maeght, Saint-Paul-de-Vence 1969. – R. NEGRI, Matisse e i Fauves, Milan 1969. – J. RUSSELL, The World of Matisse, New York 1969. – G. DIEHL, Matisse, Paris 1970. – M. GIRY, "Matisse et la naissance du fauvisme," Gazette des Beaux-Arts, 1970. – G. DI SAN LAZZARO (editor), Homage to Henri Matisse, New York 1970. – Henri Matisse. Exposition du centenaire, Grand Palais, Paris 1970. – L. ARAGON, Henri Matisse, roman, 2 vols., Paris 1971; Henri Matisse, London and New York 1972. – D. FOURCADE (editor), Henri Matisse: Ecrits et propos sur l'art, Paris 1972. – J. JACOBUS, Henri Matisse, New York 1972. – J.D. FLAM (editor), Matisse on Art, London and New York 1973 (collected writings on art). – P. SCHNEIDER, Matisse, Paris-London-New York 1984. – Matisse, exhibition catalogue, Palais des Beaux-Arts, Lille 1986 (with loans from Leningrad and Moscow).

PUY:

M. PUY, Jean Puy, Paris 1920. – J. PUY, "Souvenirs," Le Point, Colmar, July 1939. – P. GAY, Jean Puy, Paris 1944. – N. BETTEX-CAILLER, "Jean Puy," Cahiers d'Art-Documents 104, Geneva 1959. – Jean Puy, exhibition catalogue, Musée des Beaux-Arts, Lyons 1963. – F.X. STAUB, "Le peintre Jean Puy," L'Information d'Histoire de l'Art, Paris 1968. – Jean Puy, exhibition catalogue, Petit Palais, Geneva 1977.

SCHMIDT-ROTTLUFF:

W.R. VALENTINER, Karl Schmidt-Rottluff, Leipzig 1920. – R. SCHAPIRE, Karl Schmidt-Rottluffs graphisches Werk bis 1923, Berlin 1924. – W. GROHMANN, Karl Schmidt-Rottluff, Stuttgart 1956. – E. RATHENAU, Karl Schmidt-Rottluff. Das graphische Werk seit 1923, New York 1964. – G. WIETEK, Schmidt-Rottluff Graphik, Munich 1971. – K. BRIX, Karl Schmidt-Rottluff, Vienna and Munich 1971. – Schmidt-Rottluff: Die Schwarzblätter, exhibition catalogue, Staatsgalerie, Stuttgart 1974-1975. – Schmidt-Rottluff: Das nachgelassene Werk seit den zwanziger Jahren, exhibition catalogue, Brücke-Museum, Berlin, 1977-1978.

VAN DONGEN:

E. DES COURRIÈRES, Van Dongen, Paris 1925. – P. FIERENS, Van Dongen, L'homme et l'œuvre, Paris 1927. – Van Dongen, exhibition catalogue, Galerie des Ponchettes, Nice 1959. – L. CHAUMEIL, "Van Dongen et le fauvisme," Art de France, I, 1961. – Van Dongen, exhibition catalogue, Musée des Beaux-Arts, Lyons 1964. – K.F. ERTEL, "Kees van Dongen anlässlich seines 90. Geburtstages," Kunst, 1966-1967. – A. PARINAUD, "Riscoperta di Van Dongen," Arti, 1967. – L. CHAUMEIL, Van Dongen, L'homme et l'artiste, la vie et l'œuvre, Geneva 1967. – Van Dongen, exhibition catalogue, Musée National d'Art Moderne, Paris 1967. – G. DIEHL, Van Dongen, Paris 1968 and New York 1969. – M. HOOG, "Repères pour Van Dongen," La Revue de l'Art, 1971. – J. MÉLAS KYRIAZI, Van Dongen et le fauvisme, Lausanne-Paris 1971. – Van Dongen, exhibition catalogue, University of Arizona Museum of Art, Tucson 1971. – Van Dongen, exhibition catalogue, Grand Palais, Paris 1972.

VLAMINCK:

D.H. KAHNWEILER, Maurice de Vlaminck, Leipzig 1920. – F. CARCO, Vlaminck, Paris 1920. – F. FELS, Vlaminck, Paris 1928. – M. DE VLAMINCK, Tournant dangereux, Paris 1929; Dangerous Corner, London 1961. – K.G. PERLS, Vlaminck, New York 1941. – M. DE VLAMINCK, Portraits avant décès, Paris 1943. – P. MAC ORLAN, Vlaminck, Paris 1947. – M. GENEVOIX, Vlaminck, Paris 1954. – M. DE VLAMINCK, "Avec Derain nous avons créé le fauvisme," Jardin des Arts, 1955. – C. ROGER-MARX, "Vlaminck ou le fauve intégral," Jardin des Arts, April 1956. – M. SAUVAGE, Vlaminck, sa vie et son message, Geneva 1956. – C. ROGER-MARX, L'œuvre de Vlaminck. Du fauvisme à nos jours, Galerie Charpentier, Paris 1956. – J.P. CRESPELLE, Vlaminck, fauve de la peinture, Paris 1958. – Vlaminck, exhibition catalogue, Kunstmuseum, Bern 1961. – J. SELZ, Vlaminck, Paris 1962. – P. CABANNE, Vlaminck, paysages, Paris 1966. – G. BOUDAILLE, Vlaminck, Paris 1968. – A. WERNER, "Vlaminck: Wildest of the 'Beasts'," Arts Magazine, New York, March 1968. – J. REWALD, Vlaminck: His Fauve Period (1903-1907), Perls Galleries, New York 1968. – M. GIRY, "Le curieux achat fait à Derain et à Vlaminck au Salon des Indépendants de 1905 ou Deux tableaux retrouvés," L'Œil, 1976. – P. PETRIDÈS, Catalogue raisonné de l'œuvre de Vlaminck (in preparation).

Group Exhibitions

1901-1908, Salon des Indépendants, Paris. – 1903-1908, Salon d'Automne, Paris. – 1902-1908, Galerie Weill, Paris. – 1903-1908, Galerie Druet, Paris. –

October-November 1941, *The Fauves* (preface by R. Lebel), Marie Harriman Gallery, New York. – March 1947, *Chatou* (introduction by Derain and Vlaminck), Galerie Bing, Paris. – 1950, *Les Fauves und die Zeitgenossen*, (preface by A. Rüdlinger), Kunsthalle, Bern. – 1950, XXVth Biennale, Venice. – June-September 1951, *Le Fauvisme* (preface by J. Cassou), Musée National d'Art Moderne, Paris. – 1951, *The Fauves*, Sidney Janis Gallery, New York. – April-May 1952, *Le Fauvisme* (preface by B. Dorival), Musée des Beaux-Arts, Rennes. – October 1952-January 1953, *The Fauves* (preface by J. Rewald), Museum of Modern Art, New York (subsequently shown in Minneapolis, San Francisco and Toronto). – November 1960-January 1961, *Les sources du XXe siècle. Les arts en Europe de 1884 à 1914* (essays by J. Cassou, G.C. Argan and N. Pevsner), Musée National d'Art Moderne, Paris. – March-May 1962, *Les Fauves*, Galerie Charpentier, Paris. – October-November 1965, *La Cage aux Fauves du Salon d'Automne 1905* (essays by J. Cassou and P. Cabanne), Galerie de Paris, Paris. – January-March 1966, Musée National d'Art Moderne, Paris, and March-May 1966, Haus der Kunst, Munich, *Le fauvisme français et les débuts de l'expressionnisme allemand* (prefaces by B. Dorival and L. Reidemeister). – May-July 1966, *Matisse und seine Freunde. Les Fauves*, Kunstverein, Hamburg. – June 1967, *Fauves et Cubistes*, La Palette Bleue, Romanet-Rive Gauche, Paris. – November 1967-January 1968, *Autour du fauvisme. Valtat et ses amis* (essays by R. Rousseau and G. Peillex), Palais des Beaux-Arts, Charleroi. – 1969, *Les Fauves*, Galerie Beyeler, Basel. – September-November 1969, *Fauvisme in de Europese Kunst* (essays by J. Leymarie, E. Langui and D. van Daele), Cultureel Centrum Burgmeester Antoon Spinoy, Malines. – May-July 1970, *L'expressionnisme européen* (essays by J. Leymarie, P. Vogt and L.J.F. Wijsenbeck), Musée National d'Art Moderne, Paris. – November-December 1970, *The Fauves* (essays by G. Duthuit and R. Lebel), Sidney Janis Gallery, New York. – May-November 1971, *Delacroix et le fauvisme*, Musée Delacroix, Paris. – November-December 1974, *The Fauves* (preface by F. Daulte), Seibu Takatsuki Galleries, Osaka. – April-May 1975, *The Fauves* (essay by R.J. Wattenmaker), Art Gallery of Ontario, Toronto. – March-June 1976, *The "Wild Beasts." Fauvism and its Affinities* (text by John Elderfield), Museum of Modern Art, New York (subsequently shown at the San Francisco Museum of Modern Art and the Kimbell Art Museum, Fort Worth). – November-December 1978, *The Fauves* (preface by D. Sutton), Lefevre Gallery, London. – 1982-1983, *Nabis et Fauves*, Kunsthaus, Zurich, Kunsthalle, Bremen and Kunsthalle, Bielefeld.

LIST OF ILLUSTRATIONS

(Unless otherwise specified, all photographs are from the Skira Archives)

BRAQUE Georges (1882-1963): The Port of Antwerp, 1906. (19⅝ × 24″) National Gallery of Canada, Ottawa . 73

The Little Bay at La Ciotat, 1907. (15 × 18¼″) Centre Georges Pompidou, Musée National d'Art Moderne, Paris . 76

CAMOIN Charles (1879-1965): Portrait of Marquet, 1904. (36¼ × 28¾″) Centre Georges Pompidou, Musée National d'Art Moderne, gift of Mrs A. Marquet, Paris 26

CROSS Henri Edmond (1856-1910): Le Lavandou, 1904. (35¼ × 45½″) Private Collection 42

DERAIN André (1880-1954): The Bridge at Le Pecq, 1904. (38⅝ × 45¾″) Private Collection, Paris . 34

Portrait of Vlaminck, 1905. (16¼ × 13″) Private Collection 37

Seine Barges, 1906. (31¼ × 38¼″) Centre Georges Pompidou, Musée National d'Art Moderne, Paris (Photo Centre Pompidou) 39

Reflections on the Water, 1905-1906. (32 × 39½″). Musée de l'Annonciade, Saint-Tropez 49

The Port, Collioure, 1905. (28⅜ × 35⅞″). Musée d'Art Moderne, donation Pierre and Denise Lévy, Troyes . 53

View of Collioure, 1905. (26 × 32⅜″) Museum Folkwang, Essen 53

The Mountains, Collioure, 1905. (32½ × 39½″) Collection of Mrs John Hay Whitney, New York . 54

Portrait of Matisse, 1905. (18⅛ × 13⅞″) Tate Gallery, London 55

The Pool of London, 1906. (26 × 39″) Tate Gallery, London 67

Westminster Bridge, London, 1906. (31½ × 39½″) Private Collection, Paris 67

Dancer at the ''Rat Mort'' (Woman in a Chemise), 1906. (39½ × 32½″) Statens Museum for Kunst, Rump Collection, Copenhagen . 90

DONGEN Kees van (1877-1968): Fatima and her Troupe, 1906. (37 × 28¾″) Private Collection . 93

DUFY Raoul (1877-1953): The Fourteenth of July, 1906. (17⅜ × 14⅝″) Private Collection, Paris . 15

 The Port at Le Havre, 1905-1906. (24 × 28¼″) Art Gallery of Ontario, Toronto 45

 Sainte-Adresse, The Jetty, 1906. (25½ × 31½″) Private Collection 71

 The Fourteenth of July, 1907. (31⅞ × 19¾″) Private Collection, Paris 75

 Vestibule with Stained-Glass Windows, 1906. (25¼ × 31½″) Perls Galleries, New York 78

FRIESZ Othon (1879-1949): The Port of Antwerp, 1906. (23⅞ × 28¾″) Private Collection, Paris . 72

 Landscape at La Ciotat, 1907. (30¾ × 24½″) Musée d'Art Moderne, donation Pierre and Denise Lévy, Troyes 77

GAUGUIN Paul (1848-1903): Decorative Landscape, 1888. (34 × 22½″) Nationalmuseum, Stockholm . 80

GOGH Vincent van (1853-1890): The Fourteenth of July, 1887. (17⅜ × 15⅜″) Jäggli-Hahnloser Collection, Bern . 14

 Boats Moored alongside the Quay, 1888. (21⅝ × 26″) Folkwang Museum, Essen . . . 38

JAWLENSKY Alexei von (1864-1941): Still Life with a White Horse, 1912. (21¼ × 19½″) Private Collection, Lugano . 98

 Woman with Flowers, 1909. (40½ × 30″) Von der Heydt Museum, Wuppertal 99

KANDINSKY Wassily (1866-1944): Arab Cemetery, 1909. (28¼ × 38¾″) Kunsthalle, Hamburg . 96

 Improvisation 6, 1909. (42⅜ × 37⅝″) Städtische Galerie im Lenbachhaus, Munich . . . 97

KIRCHNER Ernst Ludwig (1880-1938): The Artist and his Model, 1907. (59 × 39½″) Kunsthalle, Hamburg . 87

 Woman on a Blue Divan, 1907. (31½ × 35½″) The Minneapolis Institute of Art 89

MANGUIN Henri (1874-1949): The Fourteenth of July at Saint-Tropez, 1905. (24 × 19¾″) Collection of Mrs Gilbert Holstein (Photo of the Collection) 47

MARQUET Albert (1875-1947): The Fourteenth of July, 1906. (30¾ × 24½″) Musée de Bagnols-sur-Cèze . 15

 Matisse painting in Manguin's Studio, 1905. (39⅜ × 28¾″) Centre Georges Pompidou, Musée National d'Art Moderne, Paris (Photo Centre Pompidou) 18

 Portrait of Madame Matisse, 1901. (51¼ × 38¼″) Musée Matisse, Nice 25

 Posters at Trouville, 1906. (25⅝ × 32″) Collection of Mrs John Hay Whitney, New York 71

MATISSE Henri (1869-1954): Interior at Collioure, 1905. (23⅝ × 28¾″) Private Collection, Zurich (Photo of the collector) 6

 Self-Portrait, 1906. (21⅝ × 18⅛″) Statens Museum for Kunst, Copenhagen 9

 Signac Fishing and Derain Swimming, summer 1904 at Saint-Tropez. Drawing 13

 Street at Arcueil, 1899. (8¾ × 10⅝″) Statens Museum for Kunst, Copenhagen 21

 Still Life with a Harmonium, 1900. (29 × 21¾″) Private Collection, Paris 22

 Still Life against the Light, 1899. (29⅜ × 36½″) Private Collection, Paris 23

 Self-Portrait, c. 1900. Pen and ink 31

 Signac's Terrace at Saint-Tropez, 1904. (28¼ × 22¾″) Isabella Stewart Gardner Museum, Whittemore Donation, Boston, Mass. 40

 Luxe, calme et volupté, 1904-1905. (37 × 46¼″) Centre Georges Pompidou, Musée National d'Art Moderne, Paris 43

 The Open Window at Collioure, 1905. (21¾ × 18⅛″) Collection of Mrs John Hay Whitney, New York (Photo of the Collection) 50

 Sketch for "The Joy of Life", 1905. (16¼ × 21⅝″) Private Collection 52

 Portrait of Derain, 1905. (15 × 11″) The Tate Gallery, London 55

 Woman with a Hat, 1905. (32 × 23½″) Private Collection 59

 Portrait with a Green Stripe, 1905. (15⅞ × 12¾). Statens Museum for Kunst, Rump Collection, Copenhagen 60

 Still Life with Oriental Rugs, 1906. (39½ × 55¼″) Musée de Grenoble, legs Agutte-Sembat, Grenoble (Photo Ifot, Grenoble) 65

 Brook with Aloes, Collioure, 1907. (23½ × 28½″) Private Collection, U.S.A. 81

 Blue Nude, 1907. (36¼ × 55¼″) The Baltimore Museum of Art, Cone Collection . . . 82

 The Gypsy, 1906. (21¾ × 18⅛″) Musée de l'Annonciade, Saint-Tropez (Photo RMN) 84

 Algerian Woman, 1909. (31½ × 25⅝″) Centre Georges Pompidou, Musée National d'Art Moderne, Paris 92

MONET Claude (1840-1926): Street decked with Flags, 1878. (32 × 19¾″) Private Collection 11

SCHMIDT-ROTTLUFF Karl (1884-1976): Lofthus, 1911. (34¼ × 23⅝″) Kunsthalle, Hamburg 95

VALTAT Louis (1869-1955): The Seine and the Eiffel Tower, 1904. (17¾ × 23⅝″) Private Collection 45

VLAMINCK Maurice (1876-1958): Banks of the Seine at Nanterre: Quai Sganzin, 1902. (28¾ × 36¼″) Private Collection, Switzerland (Photo Patrick Goetelen, Geneva) . . . 28

 Man with a Pipe (Le Père Bouju), 1900. (28¾ × 19½″) Centre Georges Pompidou, Musée National d'Art Moderne, Paris. Gift of Mrs Vlaminck 30

VLAMINCK Maurice (1876-1958): Interior of a Kitchen, 1904. (21¾ × 22⅛″) Centre Georges Pompidou, Musée National d'Art Moderne, Paris (Photo Jacqueline Hyde, Paris) . . . 33

Gardens in Chatou, 1904. (32½ × 39½″) The Art Institute of Chicago 35

Portrait of Derain, 1905. (10¾ × 8¾″) Private Collection 37

Outing in the Country, 1905. (35 × 45¾″) Private Collection, Paris 48

Tugboat at Chatou, 1906. (19¾ × 25⅝″) Collection of Mrs John Hay Whitney, New York 66

The Village, 1906. (35½ × 46½″) Staatsgalerie, Stuttgart 66

Landscape with Red Trees, 1906-1907. (25⅝ × 31⅞″) Centre Georges Pompidou, Musée National d'Art Moderne, Paris . 79

Dancer at the "Rat Mort", 1906. (28¾ × 21¼″) Private Collection, Paris 90

INDEX

Académie Carrière (Paris) 10, 24, 29.
Académie Julian (Paris) 19.
Agay (Riviera) 48.
Aix-en-Provence 22.
Algeria 65, 92, 94.
AMIET Cuno (1868-1961) 87.
Antwerp 16, 72-74.
APOLLINAIRE Guillaume (1880-1918) 62.
Arcueil (Paris) 21, 22, 24.
Argenteuil (Paris) 29.
Arles (Provence) 21.
Art Nouveau 85
AZBE Anton (1859-1905) 96.

Banyuls (Pyrenees) 57.
Barnes Foundation (Merion, Pa.) 64.
BARR Alfred H., Jr. (1902) 83.
BARYE Antoine (1796-1875) 26.
Bateau-Lavoir (Paris) 62, 63.
BAUDELAIRE Charles (1821-1867) 46.
Belle-Ile (Brittany) 20, 27.
BERGSON Henri (1859-1941) 16.
Berlin 88, 94, 95.
BERNHEIM-JEUNE Gallery (Paris) 11, 34, 63.
BIETTE Jean 24.
Biskra (Algeria) 65.
Blaue Reiter group (Munich) 85, 100.
BLEYL Fritz (1880-1966) 86.
BONNARD Pierre (1867-1947) 20, 22.
Bordeaux 19.
BOUDIN Eugène (1824-1898) 12, 73, 74.
BRAQUE Georges (1882-1963) 8, 10, 12, 16, 17, 51, 63, 72-74, 76.
Brittany 20, 27, 62, 97.
Brücke group (Dresden-Berlin) 16, 17, 85-91, 94-96, 98, 100.

CAMOIN Charles (1879-1965) 10, 12, 14, 19, 21, 26, 27, 46, 48, 51, 62, 63, 72.

CARRIÈRE Eugène (1849-1906) 10, 13.
Céret (Pyrenees) 51, 52.
CÉZANNE Paul (1839-1906) 12, 13, 17, 19, 20, 22, 23, 27, 42-44, 51, 83, 85, 86, 97.
CHABAUD Auguste (1882-1955) 24.
CHARDIN J.B.S. (1699-1779) 20, 21, 24.
Chatou (Paris) 10-12, 15, 16, 29-32, 34-36, 38, 51, 54, 56, 66, 68, 70, 91.
Ciotat, La (Riviera) 76, 77.
CLAUDE LORRAIN (1600-1682) 24, 73.
Collioure (Pyrenees) 16, 17, 49-57, 64, 65, 68-70, 76, 81.
Corneilla-de-Conflent (Pyrenees) 57.
CORMON Fernand (1845-1924) 10, 21.
COROT Camille (1796-1875) 20, 24.
Corsica 10, 20, 25, 57.
COURBET Gustave (1819-1877) 8.
COURTHION Pierre 74.
CROCE Benedetto (1866-1952) 16.
CROSS Henri Edmond (1856-1910) 14, 42-44, 46, 48, 49, 56, 57.
Cubism 7, 8, 16, 17, 52, 83.

Dangast (North Germany) 94.
DELACROIX Eugène (1798-1863) 19.
DELAUNAY Robert (1885-1941) 41.
Demoiselles d'Avignon (Picasso) 64, 83.
DENIS Maurice (1870-1943) 43, 44, 63.
DERAIN André (1880-1954) 10-13, 15-17, 24, 29-32, 34-39, 49, 51-57, 62, 63, 67, 69, 70, 72, 76, 83, 90-92.
DESVALLIÈRES Georges (1861-1950) 19.
DIAGHILEV Sergei (1872-1929) 98.
DONGEN Kees van (1877-1968) 10, 12, 16, 62, 63, 91, 93.
DOSTOEVSKY Fedor (1821-1881) 86.
Dresden 8, 16, 17, 85-89, 91, 94, 98.
DRUET Gallery (Paris) 12, 44, 46, 62-64.

DUFY Raoul (1877-1953) 10, 12, 15-17, 39, 44-46, 62, 71-75, 78.
DURAND-RUEL Gallery (Paris) 32.
DÜRER Albrecht (1471-1528) 19, 88.
Dutch masters 20.
DUTHUIT Georges (1891-1973) 64.

England 70.
ENSOR James (1860-1949) 85.
Estaque, L' (Riviera) 74, 76.
EVENEPOEL Henri (1872-1899) 19, 20.

Falaise (Normandy) 72.
FAURE Elie (1873-1937) 62.
Fayum portraits (Egypt) 58.
Fécamp (Normandy) 73.
FÉNÉON Félix (1861-1944) 44.
FLANDRIN Jules (1871-1947) 19.
FRAGONARD Honoré (1732-1806) 24.
FRIESZ Othon (1879-1949) 10, 12, 14, 16, 20, 44, 64, 72, 74, 76, 77.

GALLEN Axel (1865-1931) 87.
Gardanne (Provence) 51.
GAUGUIN Paul (1848-1903) 12, 13, 16, 17, 19, 20, 23, 25, 27, 36, 41, 57, 61, 64, 72, 76, 80, 82, 83, 86, 88, 97.
Gazette des Beaux-Arts (Paris) 62.
GEFFROY Gustave (1855-1926) 7.
Germany 8, 16, 17, 63, 85-91, 93-98.
GHIRLANDAIO Domenico (1449-1494) 92.
GIDE André (1869-1951) 62.
Gil Blas (Paris) 7, 63.
GIORGIONE (c. 1477-1510) 64.
GIOTTO (c. 1267-1337) 91.
GOGH Theo van (1857-1891) 37.
GOGH Vincent van (1853-1890) 11-14, 19-21, 23, 32, 34, 36-38, 41, 51, 54, 56, 57, 61, 68, 74, 85, 86, 88, 97.
GRECO El (c. 1541-1614) 58.
GRÜNEWALD Matthias (1450-1528) 88.
GUILLAUMIN Armand (1841-1927) 44.

Havre, Le (Normandy) 10, 12, 14, 44, 45, 72-74.
HECKEL Erich (1883-1944) 16, 86, 94, 95.
HODLER Ferdinand (1853-1918) 85.
HOFMANNSTHAL Hugo von (1874-1929) 34.
HOKUSAI (1760-1849) 23.

HÖLDERLIN Friedrich (1770-1843) 86.
Holland 97.
Honfleur (Normandy) 73.

IBSEN Henrik (1828-1906) 86.
Illustration, L' (Paris) 62.
Impressionism 8, 10, 19, 20, 27, 32, 44, 56, 62, 74, 85, 88, 100;
– first group exhibition 7, 62.
INGRES J.A.D. (1780-1867) 64.
Islamic art 16, 64, 100.
Italy 91, 97.

Japanese art 16, 20, 54, 100.
JAWLENSKY Alexei von (1864-1941) 16, 17, 96-100.
JONGKIND Johan Barthold (1819-1891) 12, 73.
JOURDAIN Frantz (1847-1935) 13.
Jugendstil 85, 87, 90, 96, 98.

Kairouan (Tunisia) 97.
KANDINSKY Wassily (1866-1944) 16, 17, 41, 87, 89, 96-98, 100;
– On the Spiritual in Art 100.
KIERKEGAARD Soeren (1813-1855) 86.
KIRCHNER Ernst Ludwig (1880-1938) 16, 86-91, 93, 94, 97.

LAPRADE Pierre (1875-1931) 24.
LAUTREC, see TOULOUSE-LAUTREC.
Lavandou, Le (Riviera) 42.
LHUILLIER Charles (1824-1898) 12.
LICHTWARK Alfred (1852-1914) 94.
LIEBERMANN Max (1847-1935) 88.
LINARET Georges (1878-1905) 19.
London 16, 20, 49, 67, 69, 70, 72.
LUCE Maximilien (1858-1941) 44.
Luxe, calme et volupté (Matisse) 15, 43, 44, 46, 62, 64.

MAILLOL Aristide (1861-1944) 48, 57.
MALLARMÉ Stéphane (1842-1898) 64.
MANET Edouard (1832-1883) 7, 16, 27, 46, 64.
MANGUIN Henri-Charles (1874-1949) 10, 12, 14, 16, 18, 20, 27, 44, 46-48, 51, 62.
MANTEGNA Andrea (1431-1506) 19.
MARQUE Albert (1872-1939) 7.

MARQUET Albert (1875-1947) 10, 12-16, 18-27, 39, 41, 44, 46, 48, 51, 62, 63, 70-74.
MARX Roger (1859-1913) 41.
MATISSE Henri (1869-1954) 6, 7, 9-27, 29-32, 34-36, 40-44, 46, 48-52, 55-65, 68, 69, 76-84, 86, 91-94, 96-98, 100;
– *Notes of a Painter* 17, 19, 77, 82, 92, 94.
MATISSE Madame 20, 25, 27, 42, 58-61.
MAUCLAIR Camille (1872-1945) 7.
Merion (Pennsylvania), Barnes Foundation 64.
MONET Claude (1840-1926) 7, 11, 12, 20, 68-70, 73, 74.
MONFREID Daniel de (1856-1929) 57.
MOREAU Gustave (1826-1898) 10, 12, 19, 21, 25.
Moritzburg, Lake of (Dresden) 94.
Morocco 48.
Moscow 96.
MUELLER Otto (1874-1930) 87, 96.
MUNCH Edvard (1863-1944) 85, 86, 88, 90.
Munich 8, 85, 88, 96-98, 100;
– Neue Künstlervereinigung 85, 96, 100.
Munich Secession 96.
MÜNTER Gabriele (1877-1962) 97.
Murnau (Bavaria) 98, 100.

Nabis 12, 23, 25, 41, 57, 63, 97.
Nanterre (Paris) 28.
Negro sculpture 16, 62, 88, 89.
Neo-Impressionism 12, 41, 44, 49, 52, 97.
Neue Künstlervereinigung (Munich) 85, 96, 100.
NIETZSCHE Friedrich (1844-1900) 86.
NOLDE Emil (1867-1956) 86, 94.
Normandy 16, 27, 72-74.
Norway 94, 95.
Notes of a Painter (Matisse) 17, 19, 77, 82, 92, 94.

Oldenburg (North Germany) 94.

Paris 10, 12, 16, 19, 21, 22, 29, 32, 44, 85, 98;
– Ecole des Beaux-Arts 10, 19, 21, 36;
– Louvre 11, 20, 21, 24, 32, 64, 92;
– Salon d'Automne 7, 12-14, 16, 17, 44, 52, 62, 64, 72, 77, 82, 83, 98;
– Salon des Indépendants 10, 12, 13, 15, 27, 44, 51, 62, 64, 76.

PECHSTEIN Max (1881-1955) 87, 91, 95.
Phalanx group (Munich) 89, 97.
PICASSO Pablo (1881-1973) 12, 17, 51, 62-64, 83, 86, 90.
PIOT René (1868-1934) 19.
PISSARRO Camille (1830-1903) 20, 42, 44, 46, 68.
Pointillism 10, 14, 15, 23, 25, 26, 36, 41-44, 46, 49, 57, 68, 70, 76.
Polynesian carving 16, 88, 89.
Pont-Aven (Brittany) 57, 97.
POUSSIN Nicolas (1594-1665) 20, 46, 64.
Provence 48, 51, 97.
PURRMANN Hans (1880-1966) 63, 94.
PUVIS DE CHAVANNES Pierre (1824-1898) 43, 46.
PUY Jean (1876-1960) 10, 12, 16, 24, 27, 30, 44, 51, 62-64.

RAPHAEL (1483-1520) 19.
REDON Odilon (1840-1916) 12, 13, 23.
REMBRANDT (1606-1669) 86, 88.
RENOIR Auguste (1841-1919) 13, 14, 21, 27, 31, 48.
RODIN Auguste (1840-1917) 12, 20, 23, 26, 64.
ROTONCHAMP Jean de 82.
ROUAULT Georges (1871-1958) 10, 13, 19, 62, 86, 97.
ROUVEYRE André (1879-1962) 27.
RUBENS Peter Paul (1577-1640) 24, 74.
RUSSELL John Peter (1858-1931) 20.
RYSSELBERGHE Theo van (1862-1926) 42.

Sainte-Adresse (Normandy) 71, 73, 74.
St Petersburg (now Leningrad) 96.
Saint-Rémy (Provence) 56.
Saint-Tropez (Riviera) 14, 40-44, 46-48, 52, 64, 76.
SALMON André (1881-1969) 52.
Salon d'Automne (Paris) 7, 12-14, 16, 17, 44, 52, 62, 64, 72, 77, 82, 83, 98.
Salon des Indépendants (Paris) 10, 12, 13, 15, 27, 41, 44, 51, 62, 64, 76.
SCHMIDT-ROTTLUFF Karl (1884-1976) 16, 86, 94, 95.
Secession (Munich) 96.
SEMBAT Marcel (1862-1922) 63.
SEURAT Georges (1859-1891) 13, 20, 41, 44, 46, 51, 64, 76, 85.

Sèvres (Paris) 98.

SHCHUKIN Sergei 63.

SIGNAC Paul (1863-1935) 13, 14, 27, 40-44, 46, 48, 49, 51, 56;

– *D'Eugène Delacroix au Néo-Impressionnisme* 41.

SISLEY Alfred (1839-1899) 74.

SOULIER Père 12.

Spain 48, 51.

STEIN Gertrude (1874-1946) 63, 98.

STEIN Leo (1872-1947) 63, 64, 98.

STEIN Michael and Sarah 63.

STRINDBERG August (1849-1912) 86.

Tahiti 57, 82.

TERRUS Etienne 57.

Toulouse 10, 20, 24, 57.

TOULOUSE-LAUTREC Henri de (1864-1901) 22, 41, 72, 85, 86, 88, 91.

Trouville (Normandy) 71, 73.

TSCHUDI Hugo von 100.

Tunisia 97.

TURNER J.M.W. (1775-1851) 20, 49, 70.

United States 63.

VALLOTTON Félix (1865-1925) 88.

VALTAT Louis (1869-1955) 12, 14, 16, 45, 48, 49, 62, 63.

VAUXCELLES Louis (born 1870) 7, 44, 46, 62, 64, 77, 94.

VERKADE Jan (1868-1946) 97.

Vésinet, Le (Paris) 32.

Vienna 88.

Villa La Hune, Saint-Tropez (Signac) 40, 42, 44.

VLAMINCK Maurice (1876-1958) 7, 10-12, 16, 28-39, 48, 49, 51, 54, 55, 62, 63, 66, 68-70, 76, 79, 90-92.

VOLLARD Ambroise (1868-1939) 14, 23, 32, 41, 63, 68, 69.

VUILLARD Edouard (1868-1940) 13, 25, 41.

WEILL Berthe 12, 46, 62.

WEREFKIN Marianne von (1870-1938) 96.

WHITMAN Walt (1819-1892) 86.

WORRINGER Wilhelm (born 1881) 100.